ABANDONED
MICHIGAN
DOORWAYS TO DECAY

KYLE BROOKY

AMERICA
THROUGH TIME®
ADDING COLOR TO AMERICAN HISTORY

America Through Time is an imprint of Fonthill Media LLC
www.through-time.com
office@through-time.com

Published by Arcadia Publishing by arrangement with Fonthill Media LLC
For all general information, please contact Arcadia Publishing:
Telephone: 843-853-2070
Fax: 843-853-0044
E-mail: sales@arcadiapublishing.com
For customer service and orders:
Toll-Free 1-888-313-2665

www.arcadiapublishing.com

First published 2019

Copyright © Kyle Brooky 2019

ISBN 978-1-63499-173-5

Typeset in Trade Gothic 10pt on 15pt
Printed and bound in England

CONTENTS

tattered walls
from ceilings split
and bed frame
holding mothball mattress

someone left the tub running
teardrops from the sky
down into the floorboards
where rocking horse sits
like cement hardened
from screams and silence

main street diner with
smudged red booths
the milkshake machine was a hit
until the neighbor kids
tasted their first drop
of aged Jim Beam

do the church bells still ring
when there's no one to listen?
do the curtains still call
in an empty theater?
does the neighborhood still watch
over hollowed trailers?

is a house not a home if the sun
still rises in the east
and sets in the west
but even the birds
lost track
of their way back

and now they sit
in stillness
wanting nothing more
than to be seen.

Faith Lee

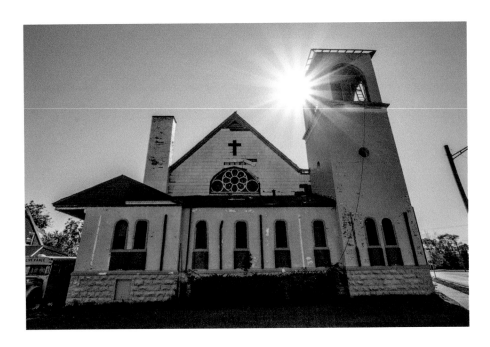

INTRODUCTION

While writing the first *Abandoned Michigan* book, I quickly realized that there were so many locations I had to leave out. Since the book was already going over the contracted word and picture count, I reluctantly had to pick and choose.

By no means is this to say these locations are in any way inferior; I simply had to decide on a certain amount in each category to provide a well-rounded look at each. This brings me to the one category that was dropped completely from the first book: churches.

Outside of Detroit, Michigan is not known for its abandoned places of worship. At the point of writing, I had only a few shots and decided to make sure I would devote the time before this book to find as many as possible.

Albeit exciting for those who explore these places, the sad truth is that there will always be someplace new that is abandoned. Hundreds of businesses are closed across the state each year, some to never be reopened. Homes are foreclosed. Budget cutbacks see schools and other government-funded places scaled back or closed outright.

While Michigan and the rest of the country is not in a state of economic depression that it reached around 2008, there is still a struggle. The state's unemployment rate is still 0.3% higher than the U.S. average. The average annual income is roughly $6,000 lower than the U.S. average.

Cities such as Detroit, Flint, Pontiac, and Saginaw are still rife with abandonment. The countryside is littered with remnants of forgotten towns, farmhouses stand vacant, and stores collect dust on their shelves.

As with the first book, we will be looking at locations both known and unknown, as well as the history both pre- and post-abandonment. The purpose behind these books as well as our main exploration channel, *Ruin Road*, is to preserve and document the current state of these buildings, but also to learn about the history behind them.

Unfortunately, all-too-often passersby, neighbors, or city officials are quick to dismiss these buildings as blight and call for their demolition with little regard or knowledge of the sometimes-historic events that took place within. After all, as they say, those who forget their past are doomed to repeat it.

1

BUSINESS AND INDUSTRY

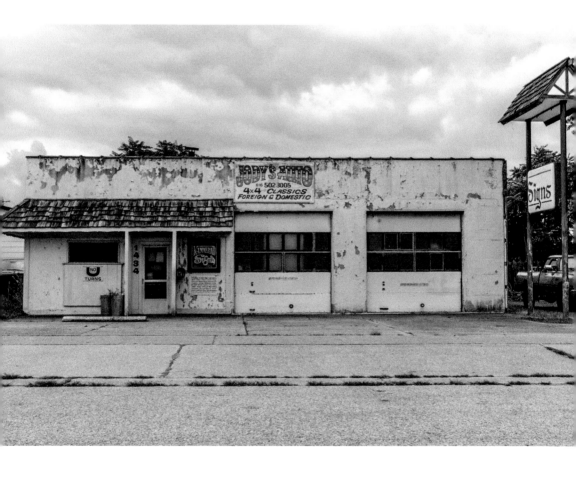

Parchment Paper Mill

The first paper mill in the Kalamazoo region opened in 1867, and by 1902, no less than nine paper mills were located in and around what had become known as "The Paper City." In 1909, local entrepreneur Jacob Kindleberger purchased an abandoned sugar beet factory along the Kalamazoo River to start his own paper factory. In addition to his keen business sense, Kindleberger envisioned a city for his workers to live around the growing Kalamazoo Vegetable Parchment Co.

This city began as tents spread around the factory while Kindleberger began buying surrounding property and selling it to his employees at fair rates they could afford. Growing to a population of more than 500, Parchment officially became a village in 1930, being labeled as "a neat, well-painted town" by *Reader's Digest* in 1932.

KVP continued to provide for the community until the Great Depression, when its citizens voted to turn Parchment into a city, thereby alleviating much of the burden on the company. Coming out of the depression strong, KVP employed more than 1,700 workers in the 1940s and 1950s, becoming known as "the world's model paper mill."

Their output was a variety of parchment-based paper products such as kitchen parchment, paper packaging, paper plates and cups, and garbage paper, as well as wax-lined aviation maps during World War II. At the company's height, roughly 2,400 people were employed at KVP.

Beginning in 1960, the company merged and was bought out several times, staying in business while many other local mills began closing with the decline of the industry starting in the 1970s. The Crown-Vantage Co. was the final business to use the factory, closing in 2000.

Eight years later, a Colorado-based company purchased the eighty-four-acre property with plans of developing it into a mixed-use retail and residential property. Two million dollars was spent demolishing several buildings, and the first phase of development was announced to be completed by 2012; however, that was the end of any work done on the site. Several fires broke out on the property in the following years, sparking concern and outrage from local citizens.

Several other companies expressed interest in the property, but it remained in the idle hands of the development. Finally, in 2018, the city demanded the property either be returned to them or demolished within the year by the owners. That same year, the city's water source was discovered to contain high amounts of PFAS, a toxic compound. It was quickly determined that the mill had indeed used the contaminants in its production of food contact paper, as a means of resisting grease. The waste was disposed of in the company's landfill, located less than one mile from the contaminated drinking water source wells.

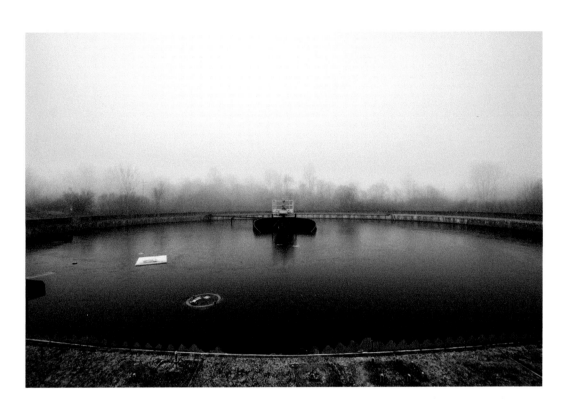

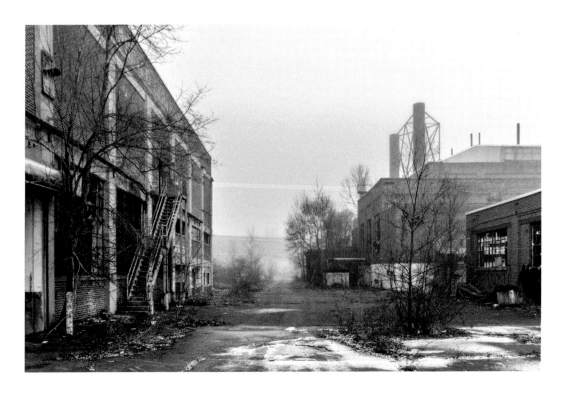

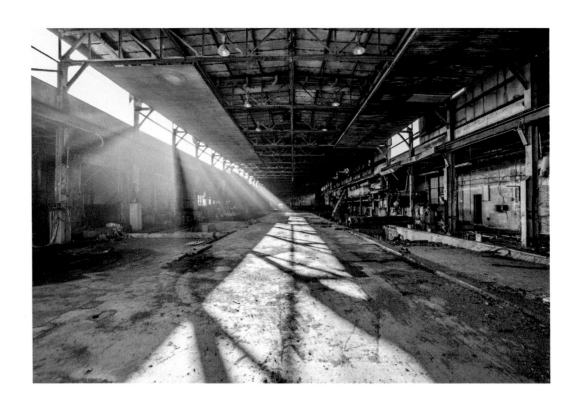

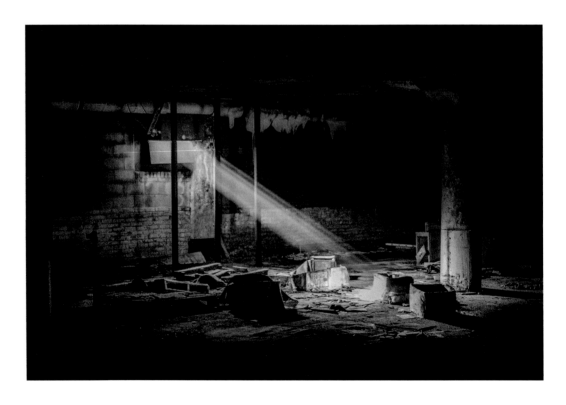

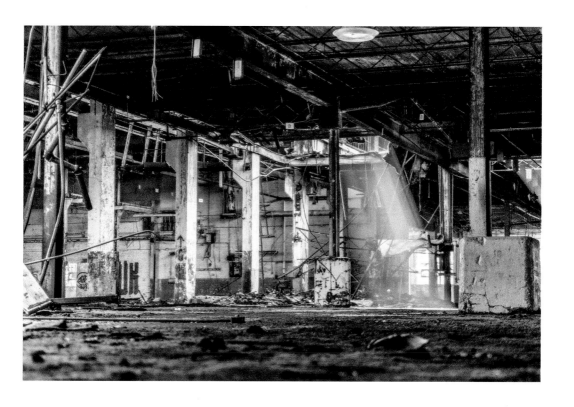

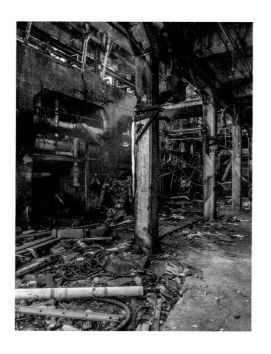

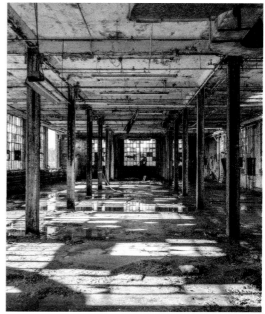

BAKER PERKINS

In 1914, Werner & Pfleiderer Co., a manufacturer of mixing and kneading machines for baking bread, constructed their new factory in Saginaw. When the U.S. entered World War I, the company was one of many seized by the government for being German-owned.

Post-war, the factory was purchased by Baker Perkins Inc., which moved its sales division from New York. Ironically, within a few years they would partner with W&P and flourish, constructing a large machine shop and expanding the foundry and other buildings, eventually taking up twenty-two acres.

However, the partnership was severed in 1934 when profits owed from W&P were held by the newly formed Nazi government in Germany. Like most factories, the World War II years saw BP receive numerous defense projects, producing such things as destroyer boat hulls, boat propellers, air raid sirens, explosives mixers, a portable bakery unit, and even military landing crafts, some of which were used on D-Day.

The end of the war saw the closure of many similar baking businesses and equipment manufacturers. BP remained in business due to a continued partnership with the government. For a short time in 1956, uranium was on site as the company helped develop nuclear weapons for the Department of Energy.

In the 1960s, despite labor strikes and low business, they began mixing rocket fuel for America's space program. Eventually, like so many other Michigan-based companies, they moved elsewhere due to high labor costs, and by 1987, the entire factory closed permanently.

Several smaller machine companies leased the property until 2010 when the property's owner passed away. Within a year, partial demolition took place, with only the valuable steel taken. At the same time, the new owners ceased paying taxes and the land bank took ownership in 2014. The following year, the U.S. Environmental Protection Agency demolished further portions and removed contaminants.

Since then, Baker Perkins has sat unused, with no current plans for further demolition.

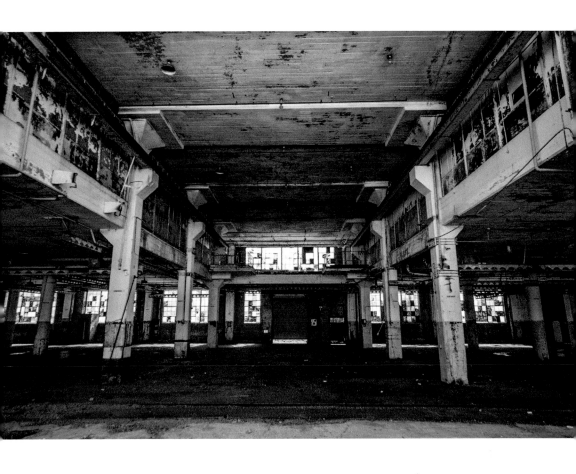

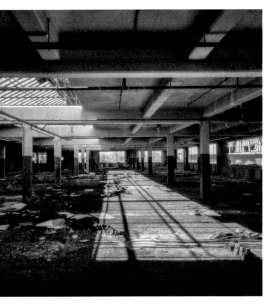

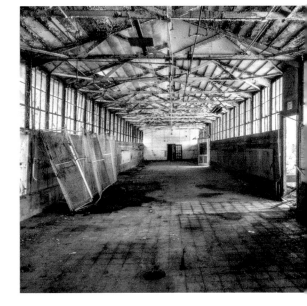

CLINTON WOOLEN MILL

As the historic marker out front, erected in 1979, notes, the mill was a vital part of the local economy and was the primary employer in the area, processing fleece into wool cloth and fabric, as well as a complex dye processing system. Constructed in 1867 at a total of $95,000, the original mill was burned to the ground just nine years later. The mill was rebuilt as the current structure, thanks largely in part to the village's citizens, who, together, raised $10,000 to rebuild the mill in just three weeks' time.

Soon, the mill began manufacturing cloth used for uniforms and coats, receiving an Award of Excellence from the U.S. Army and Navy in 1942. Their biggest customer, however, was the automobile industry in Detroit, which began moving from wool upholstery to synthetics. The mill closed in 1957, one of the last woolen mills in the area.

Since then, the mill has been largely abandoned; only part of the office building has been converted into several small businesses and another outer section converted into apartments. In 2007, a suspicious fire broke out in the mill, taking nine fire departments to control the blaze.

Just two years later, another fire broke out in the also-abandoned Atlas Feed and Grain Mill, situated directly behind the Woolen Mill, and is noted as being the second-oldest business in the state, beginning in 1836 and operating until 2006. Left irreparably damaged, Atlas was demolished in 2009. Clinton Woolen Mill remains standing, for the time being.

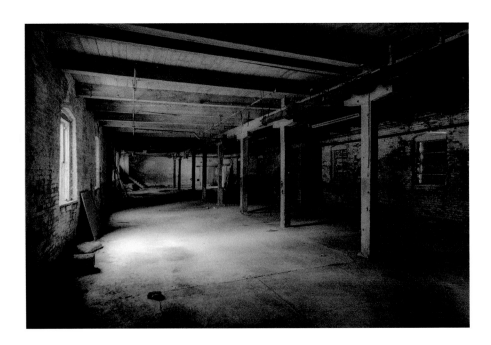

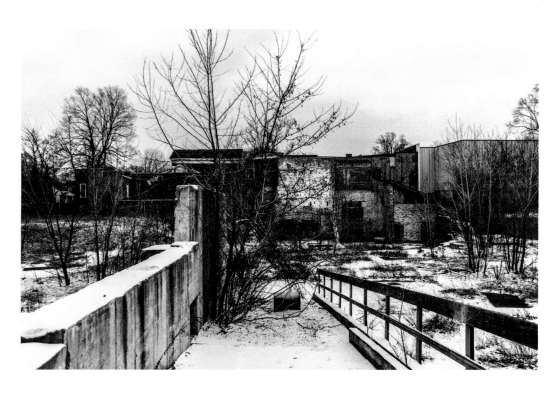

NARTRON AIRFIELD

Seeking a way to keep in better touch with its customers and other businesses, James Miller thought of a solution for his aluminum manufacturing business located in Reed City: an airport. In 1954, the first airport was constructed but had to be moved when the state's plan for U.S. Highway 131 ran directly through the site.

Miller decided his new airport would be even bigger and better, prompting the addition of Miller Auditorium. Utilizing the company's signature extruded aluminum channels in its design, the auditorium could hold 1,200 people for company functions. The building also included an all-aluminum "dream kitchen," meeting rooms, and office rooms, while the airport control tower was on the second floor. A hydro-electric dam provided power for the airport, two runways, and hangars.

The facilities were purchased in 1979 by the Nartron Corp., an electronic parts supplier, as its engineering and manufacturing facility. Until the late 1980s, the building was also used for advanced product development and product assembly. Today, Nartron still uses the hangar building for storage, but Miller's airport remains empty, with many windows and doors busted out.

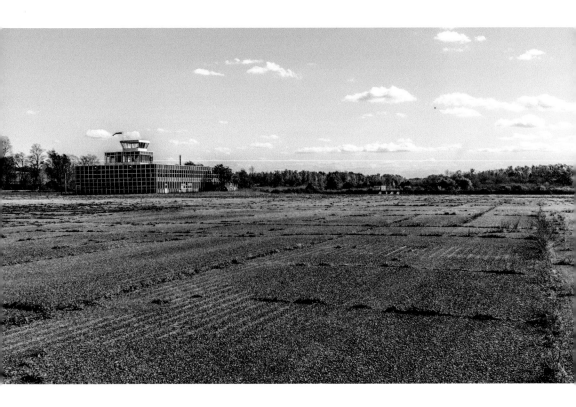

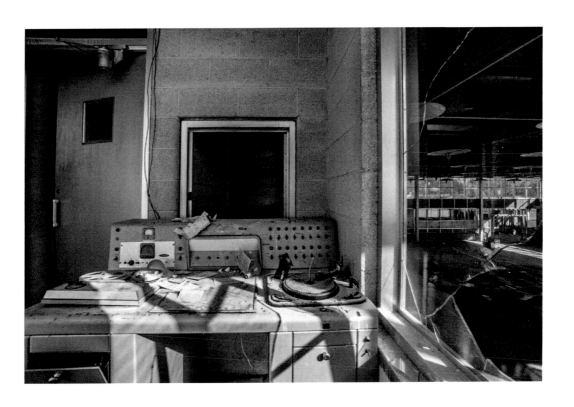

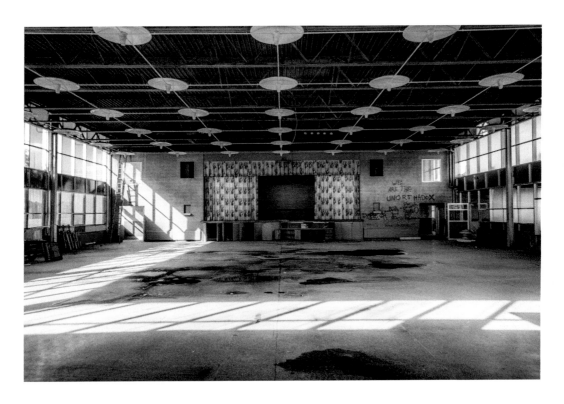

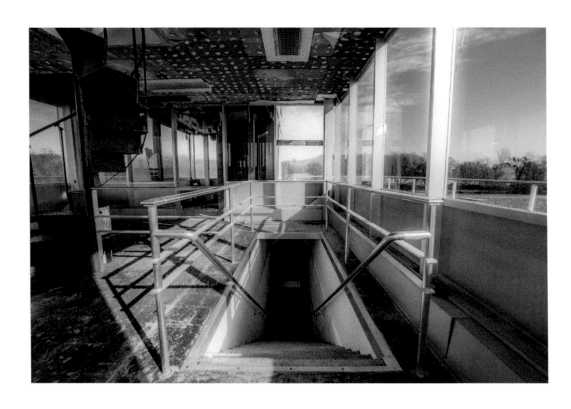

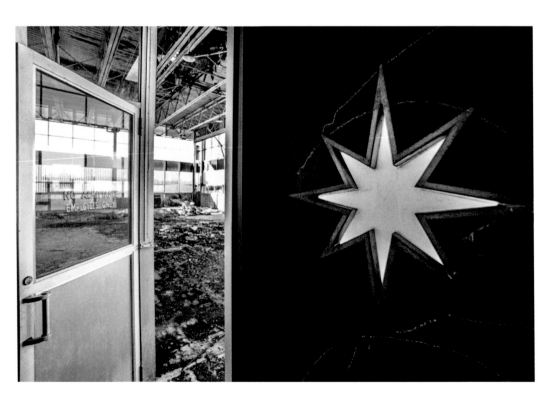

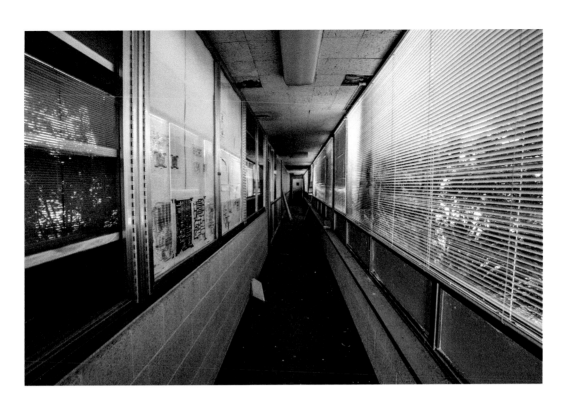

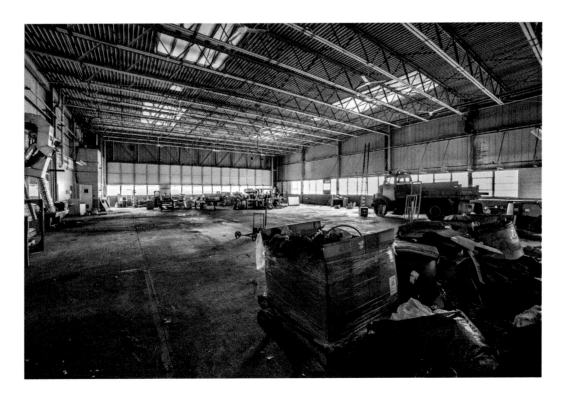

2

TOWNS AND NEIGHBORHOODS

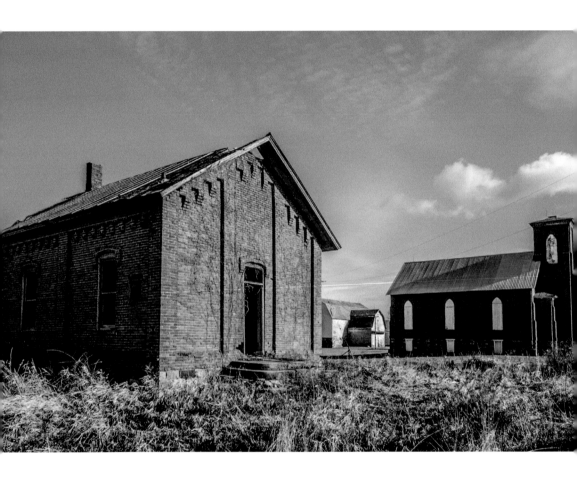

St. Joseph Car Graveyard

A resort town in the lower half of the state, St. Joseph sits atop a bluff overlooking Lake Michigan. Like many towns along the lake, a harbor is situated along the downtown section. In the 1930s, officials sought to protect the harbor from inclement weather and constructed a set of piers, setting into motion a chain of events quite literally causing a neighborhood to be swallowed by the water.

With the new piers, the water current was altered and began to eat away at the high bluffs, upon which a residential neighborhood sat. By the 1940s, residents began to take notice and built erosion-control structures on the beaches below their homes.

However, each new structure worsened the erosion for the next neighbor, causing them to build a structure and transfer the problem farther down the shore. Soon, more than 100 feet of the bluff had disappeared and more than twenty homes had either been moved or fallen into the lake below.

In a last-ditch effort, remaining homeowners tossed the wrecks of more than 150 cars and other debris over the bluff to form a makeshift erosion-control barrier before the state stopped them.

Today, the land is undevelopable. The homes are long gone. The land that remains has been turned into a lookout park, with a placard telling the story of the long-gone neighborhood. But if you hike down the overgrown and still-eroding bluffs, you will find the wrecks of old automobiles, concrete slabs, and anything else those desperate homeowners could push down there.

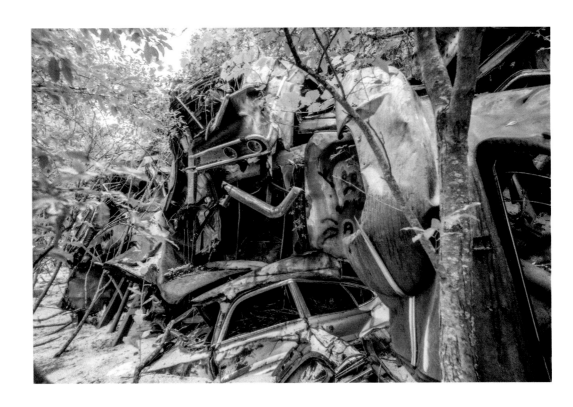

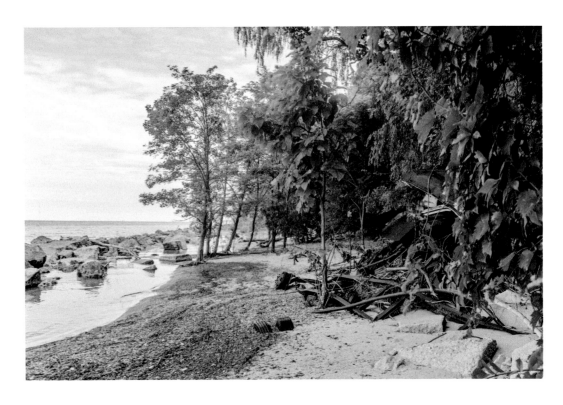

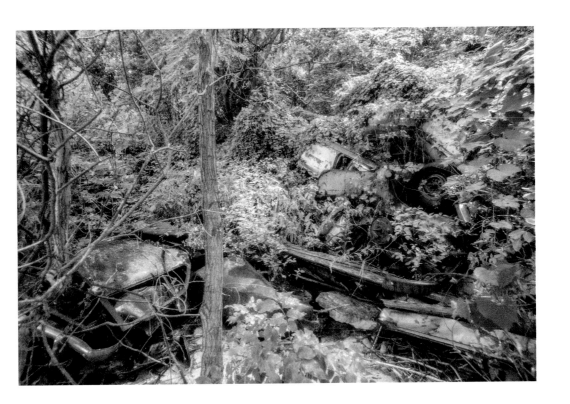

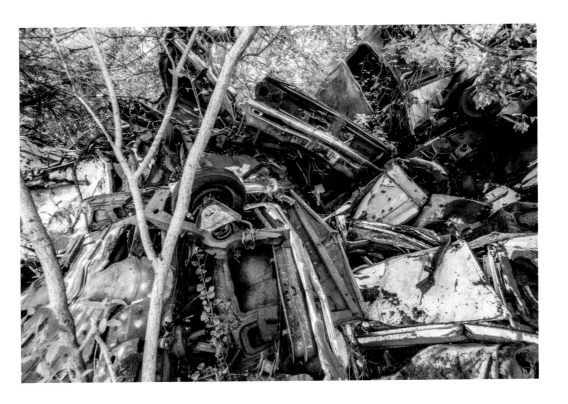

White Pines Estates

Originally named Deals Mobile Home Park in 1963, this fifty-eight-lot trailer park in Mattawan closed in April 2017 for unknown reasons. Strangely, most trailers were left behind along with the residents' belongings, though a note on one trailer informed anyone concerned that the owner planned on returning and living there in the future.

A few months after closing, it was listed for sale, but it was soon taken off the market. Across the street sits a school, and though a newspaper article raised concerns about the empty trailers being dangerous for the schoolchildren, the building is not actually an active school; instead, it is only utilized as office buildings for the public school system.

Online rumors suggested that the school system had purchased the property with the intention of turning the land into a parking lot and, in mid-2018, all trailers were demolished.

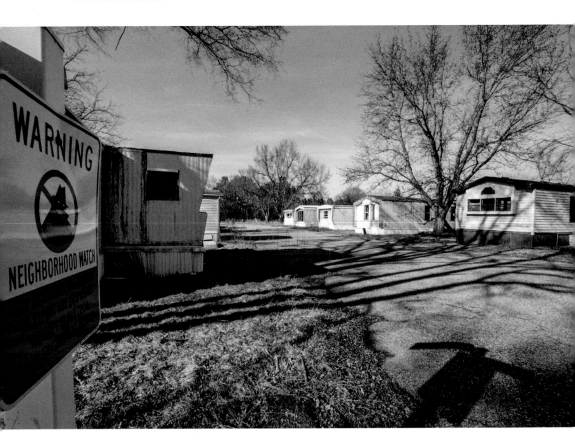

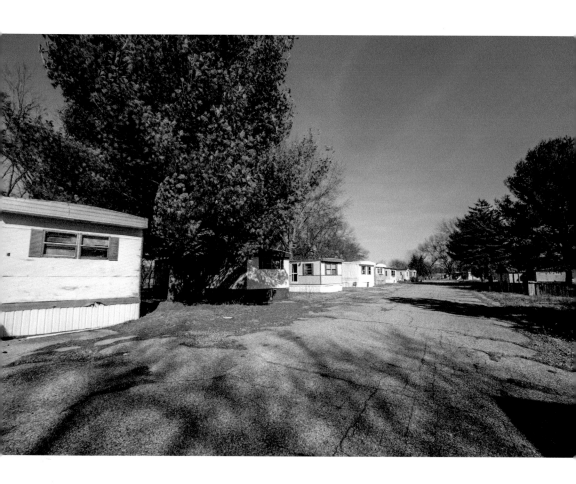

BUTTERNUT

It is unknown just when Butternut was first formed, but a census map in 1897 shows a well-established town, including a hotel, post office, cheese factory, lumber mill, and several other stores.

Although owned by the Grand Trunk Railroad, the railway did not officially operate as one until the 1920s. It later became a Grand Trunk Western railway. The Toledo, Saginaw, and Muskegon railway reached nearby Carson City in 1887, and passed through the land that became Butternut the following year.

The railroad tracks were removed in the 1950s, which spelled doom for Butternut, which became a ghost town soon thereafter. Today, the remaining buildings are on private land and in disrepair.

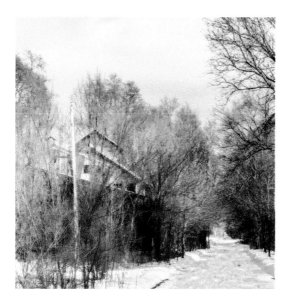
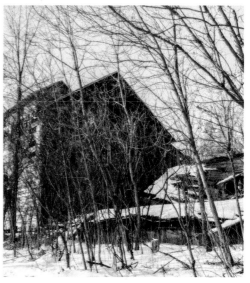
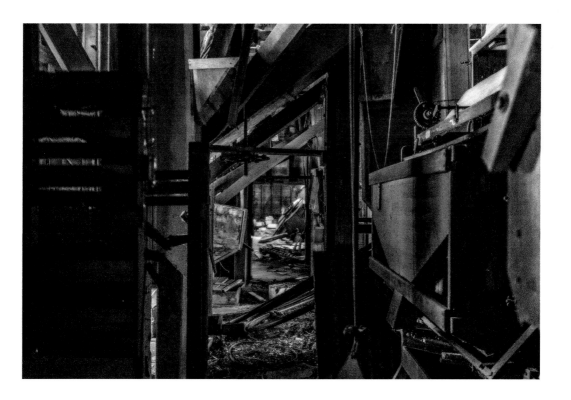

3

SCHOOLS

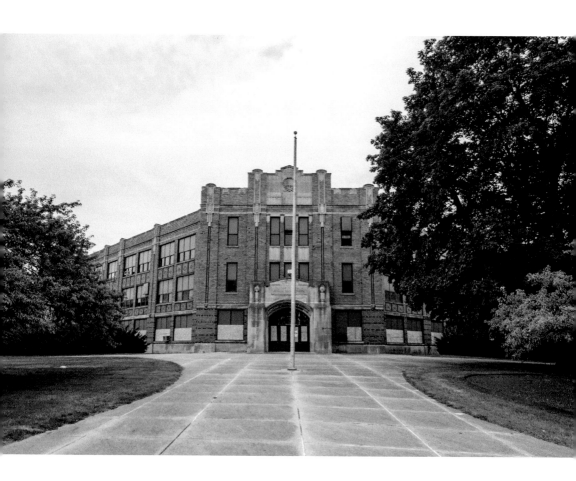

Allen School

Located not far from the Michigan/Indiana border, the town of Allen had just 188 residents at the time of its last census in 2016. However, in the late 1800s, the population was a bit larger at 594 and the Allen High School was constructed in 1869. The 1904 graduating class was a whopping three students.

A fire saw the school destroyed in 1913, and a quick plan for a new school was made in a matter of weeks. The new Allen Schoolhouse operated until 1945, when the district voted to merge its classes with another district to save money after being urged to do so by the state.

The school has sat vacant since, and was purchased in 2014 with the plans of renovating it into an antique shop, a plan which has fallen through.

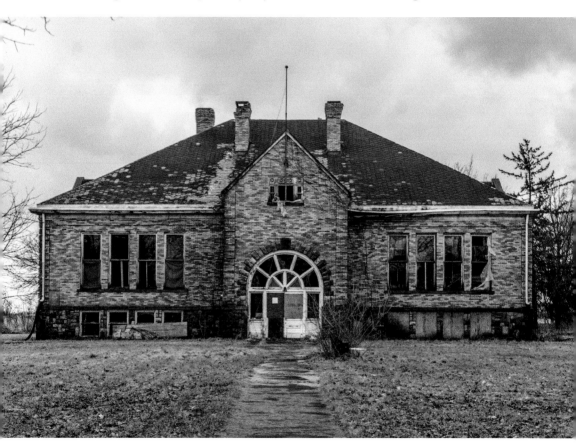

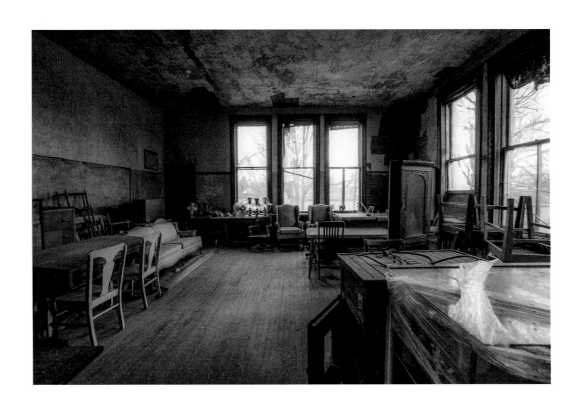

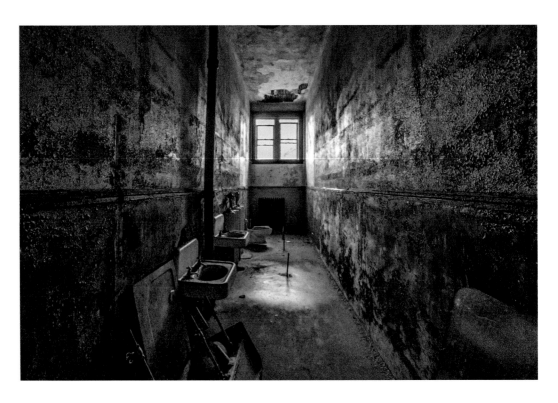

WASHINGTON MIDDLE SCHOOL

Washington Middle School was built in the 1920s near the center of the then-growing city of Pontiac. Around the 1960s, an extension was added in the back, adding a cafeteria, kitchen, and more classrooms. Roughly 675 students were enrolled in 1988, a number which dropped to 419 in 2006. With state budget cuts, a growing deficit and low enrollment rates, Washington was one of many Pontiac schools closed in 2006.

The building was one of eight schools purchased by a local investor in 2014 for a sum of $800,000. The school remained shuttered, however, until attracting the attention of Venture Inc., a nonprofit community housing organization, in early 2018.

At an estimated cost of $10.9 million, the group plans to redevelop the school into thirty-nine low-income, senior housing apartments, as well as community space and programs. However, the plan has met with opposition from members of the surrounding community, who fear their historic neighborhood will be introduced to a higher crime rate with the introduction of low-income housing.

Venture Inc. is currently in the process of securing funding to purchase the building. Meanwhile, Washington Middle School remains vacant.

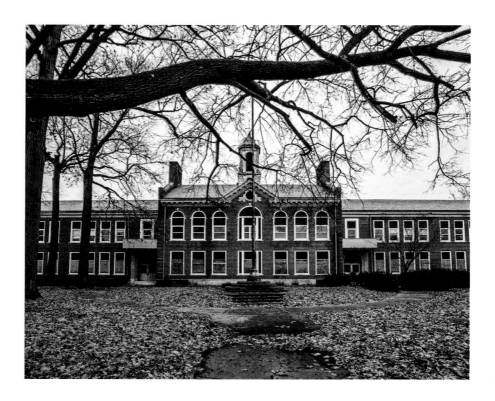

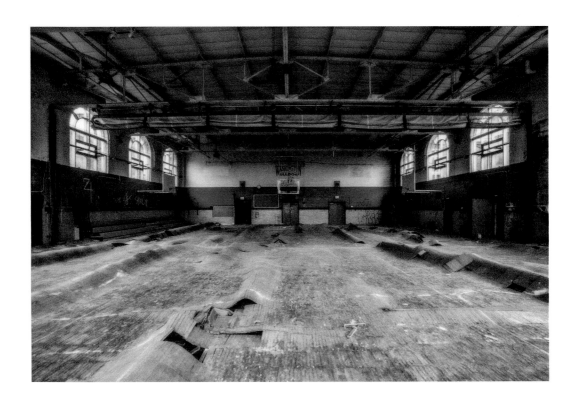

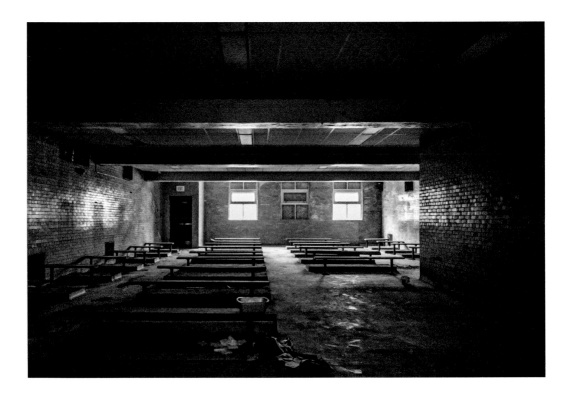

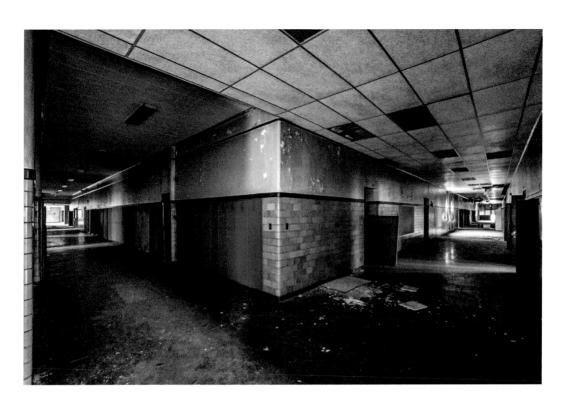

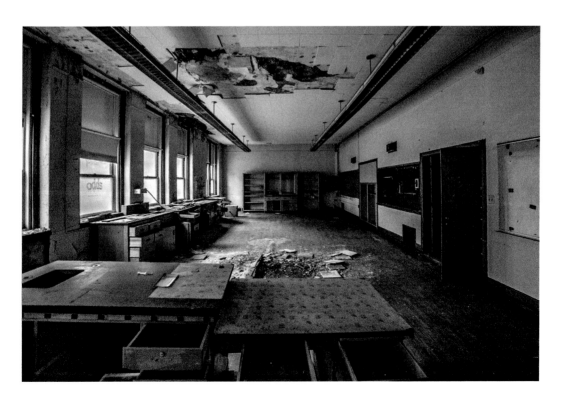

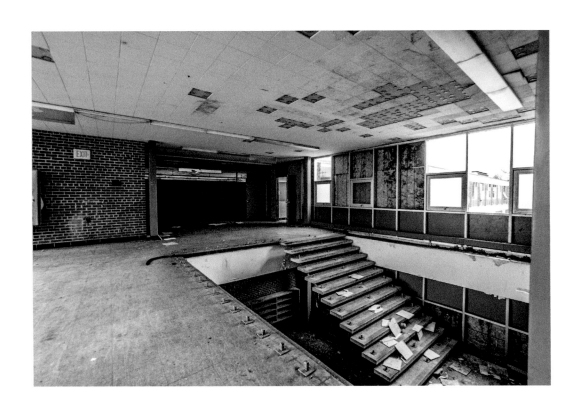

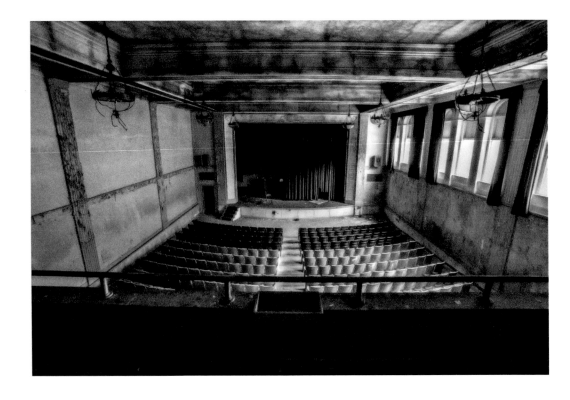

Portage Lake Observatory

The University of Michigan's first official astronomy course began in 1852, and the school's own observatory was finished just two years later, located at the heart of the campus in Ann Arbor. As the university and town around it grew, a more rural location became necessary for its observatory, and, in 1929, 200 acres of land were purchased around Portage Lake.

The following year, using donated funds, a 98.5-inch mirror was constructed with the intentions of going into a telescope on the new observatory, but no such observatory was built on the land until 1950. By then, the original telescope mirror had been given back as it had not been in use, and a 36-inch telescope had to be constructed for the new observatory.

In 1955, a second parcel of land nearby reserved for the U-M Astronomy Department had a second observatory built on it. It was named the Peach Mountain Observatory. Instead of the typical dome observatory style, this featured a radio dish, and, in 1959, an observatory with a flat, retractable roof was built on the same parcel.

Further confusing things, a second, larger dome-shaped observatory was constructed on the Portage Lake parcel in 1969. This observatory housed a 1.3-meter reflecting telescope until 1975, when the Portage Lake complex was closed, and the telescope was moved to its current location at Kitt Peak National Observatory in Arizona.

Since that time, both observatories, the astronomy residence building, and a maintenance garage have remained closed, but maintained by the university. Peach Mountain Observatory remains in use.

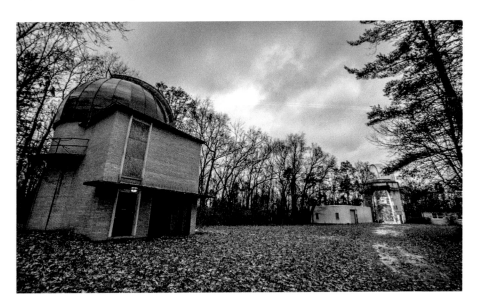

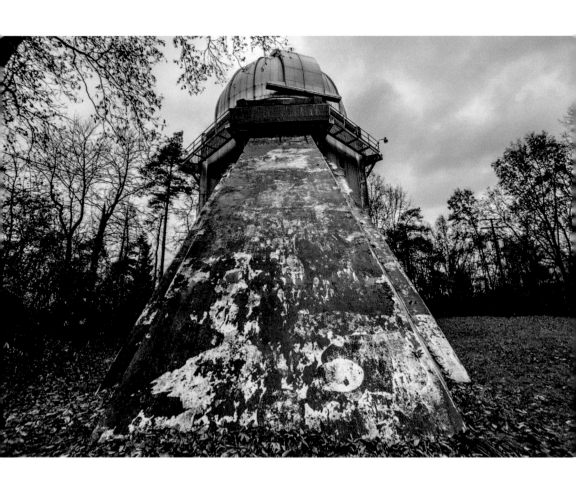

SCHOOLHOUSES

Clark Corners

Located in Imlay Township, the Clark Corners schoolhouse is the final building remaining in what was once a small town back in the 1860s. In addition to the school, a post office, mill, grocer, and blacksmith were all located in the area.

Mail stopped being delivered to the post office prior to 1900, and the other businesses faded out, as well. The school operated until the 1950s.

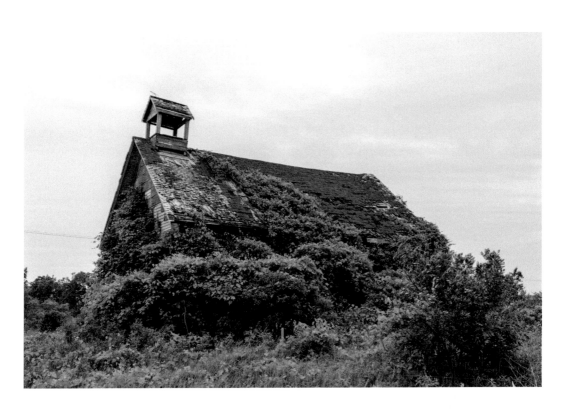

Fern Schoolhouse

Just south of Scottville, amidst a large cornfield, lies the last remainder of the town of Fern. Centered around the local sawmill, a railroad station was constructed here in 1886 and the town bloomed, two years later receiving its own post office.

The current school was constructed in 1906. Somewhat unique to schoolhouses in the state, it featured a second story, used for storage space. The ground-floor classroom included a stage for plays, chalkboards on the front and back walls, and two terrariums on both side walls for frogs and insects.

One year after the school's construction, the post office closed. Sometime later, the mill and station closed. The school operated until 1959 and is the only remaining sign of the town's existence.

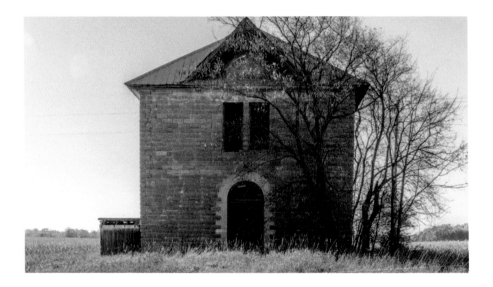

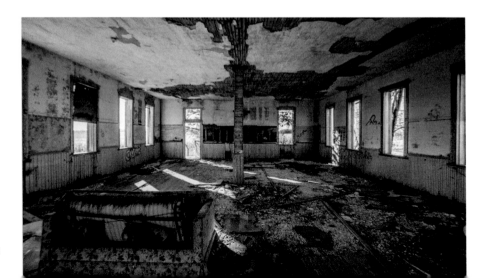

Factoryville Schoolhouse

Not much is known about the town of Factoryville, which, in 1854, was noted as a village of about 200 residents. The schoolhouse appears on an 1893 map and is later seen in a photograph from 1910. By 1930, the school and post office no longer appear, the town likely dying with the closure of the railroad it was settled next to. Today, the only remnants are the schoolhouse and adjacent cemetery.

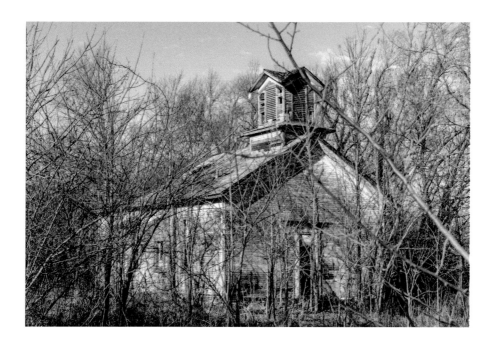

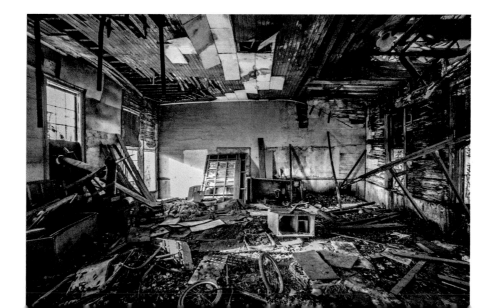

4

CHURCHES

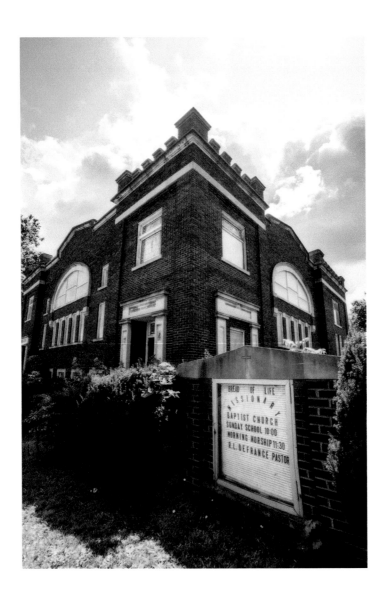

WATERVLIET

Constructed in 1896, the St. Joseph Church served as the main Catholic parish in the area. After the nearby Rush Lake mission closed, the pews from that building were used in the new church. In 1952, it grew to include a school until being sold when a new church building opened in 1961. Since that time, the original structure has exchanged hands several times, primarily remaining vacant and in disrepair. The building was eventually condemned, but demolition plans were halted in 2014, when the parcel was discovered to be a part of the adjacent former rectory, which was being lived in at the time.

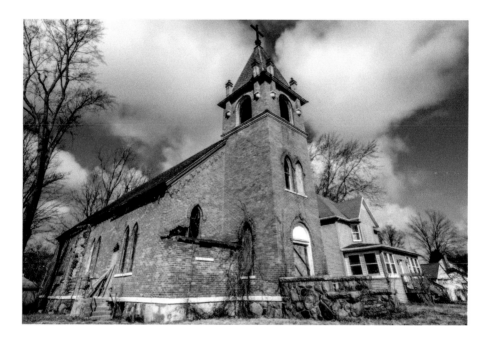

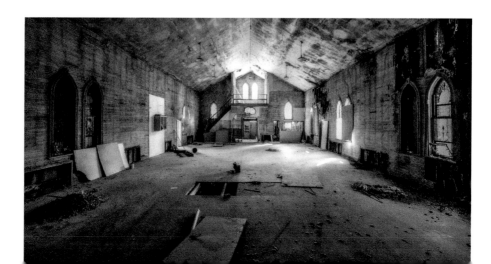

MARTIN CORNERS CHURCH

Prior to its construction in 1888, church services were held in the one-room school-house across the road. Named Martin Corners after the landowner whose property both buildings resided on, the schoolhouse first opened in 1858, with the current building constructed in 1901.

In 1894, the pastor was C. W. Jones, and though the first few years the Methodist church had a different pastor, it was Jones who purchased the land and donated much of the lumber used in its construction. For nearly 100 years, the church was used for various charity events, ice cream socials, church suppers, Christmas and Easter programs, and more, until 1971, when the congregation had become so small it was voted to abandon the church following Christmas celebrations of that year.

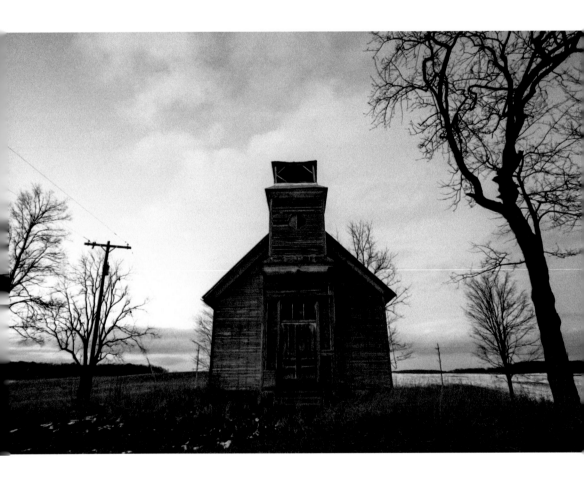

MOOREVILLE METHODIST CHURCH

The village of Mooreville was formed in 1830 and named after its founder, New York native John Moore. This Methodist church was one of two churches built in the village in 1849. It operated for ninety years before closing.

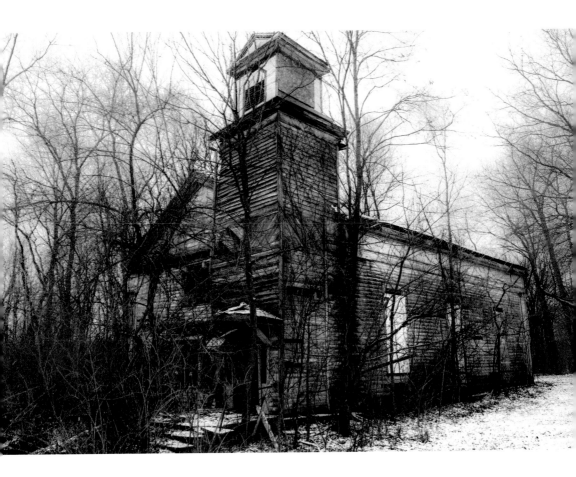

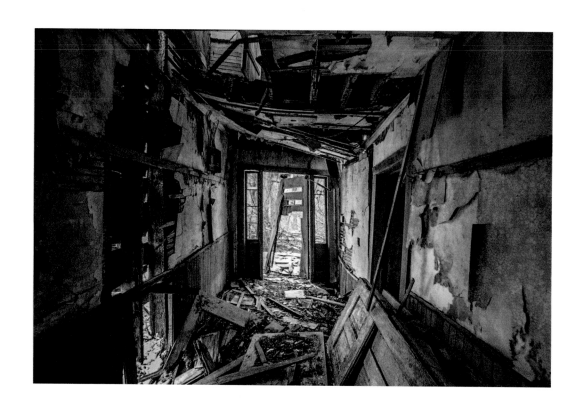

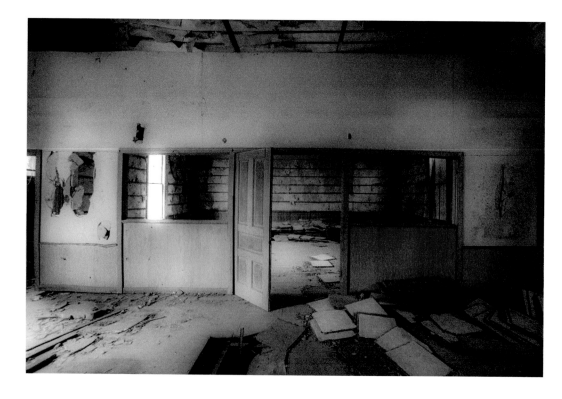

5

HEALTH AND GOVERNMENT

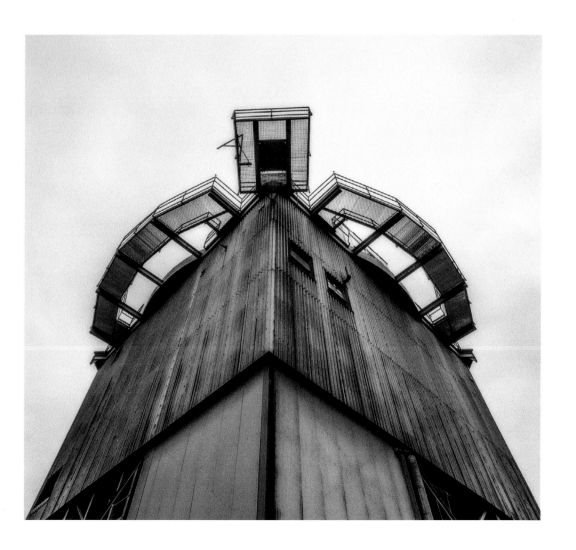

TRAVERSE CITY STATE HOSPITAL

When it was announced that a third psychiatric hospital was to be built in Michigan in the late 1800s, many cities vied to be the location chosen, as it meant an influx of jobs and economy. Using his power and influence, lumber baron Perry Hannah, known as the "father of Traverse City," secured his city in northwest Michigan as the location, and construction on the North Michigan Asylum for the Insane began in 1883.

Utilizing the Kirkbride Plan for asylum design, the hospital featured a large central administration building, known as Building 50, with wings on each side to house patients separated by their afflictions. All rooms were designed to allow maximum sunlight and airflow, a belief prevalent of the time that exposure to both had a curative effect.

By 1903, the hospital had grown to include twelve additional housing cottages and two infirmaries. Unlike many asylums of the time where patient abuse and other atrocities were committed, North Michigan Asylum's superintendent, Dr. James Decker Munson, believed in the philosophy of "Beauty is therapy." Along with the sunlight and open air, patients were treated with kindness. Flowers and trees were spread across the manicured lawns, helping them to feel more at home rather than imprisoned.

Male and female patients were housed apart with separate dining halls for each. They ate on fine china, the hallways outside their rooms were full of chairs, and the walls were adorned with artwork. Straightjackets and other restraints were forbidden at the hospital unless absolutely necessary; instead, patients were encouraged to learn trades such as furniture construction, farming, and fruit canning as part of their therapy.

With the advent of tuberculosis, typhoid, diphtheria and other outbreaks, the hospital devoted wings to the treatment of these diseases as well as the mentally handicapped. However, as drug therapy began to rise in popularity in the 1950s, many asylums began to see a drop in patients. Along with the decline of institutionalization and budget cuts, these locations began closing across the country, and Traverse City State Hospital, as it had become known, closed in 1989.

The grounds sat abandoned for more than twenty years and were planned for demolition until purchased in 2000 by The Minervini Group. Planning a mixed-use residential and commercial development, they have since began restoring the grounds. Today, Building 50 is completely restored, along with several other cottages. Visitors can shop in the numerous stores inside, eat a meal in the restored dining hall, or live in the restored cottages.

At the time of writing, several cottages, the power station, and stables remain vacant but secured. The group offers tours of some buildings, as well as a walk through the tunnels below.

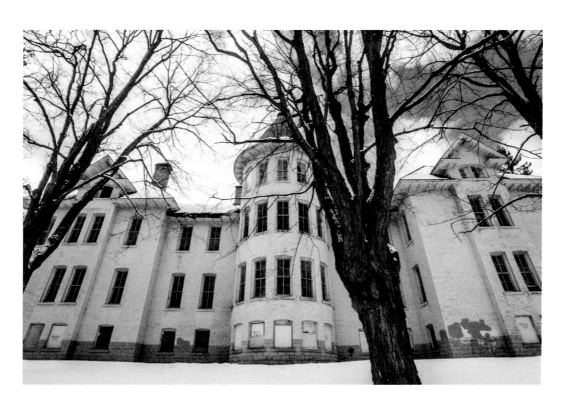

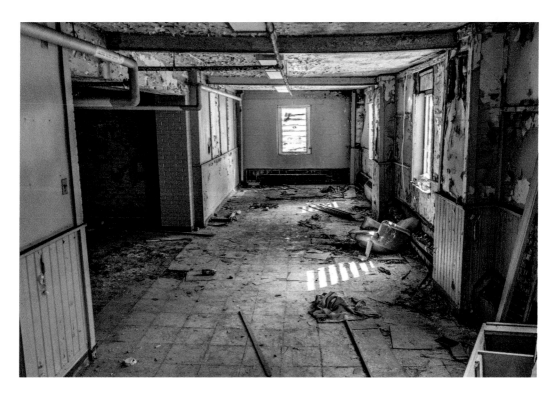

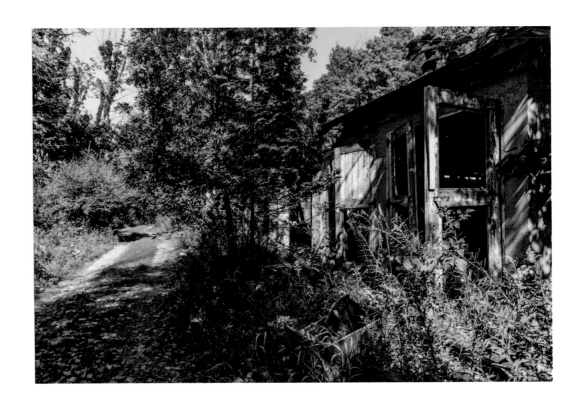

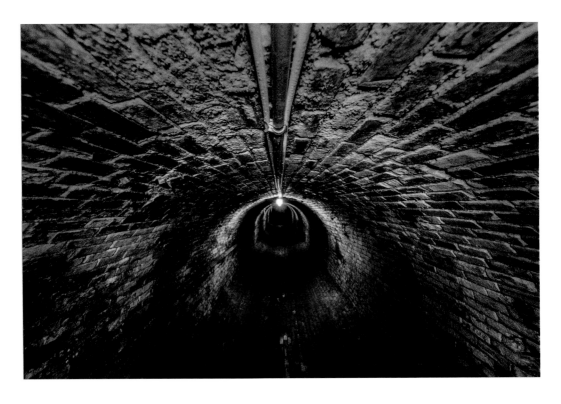

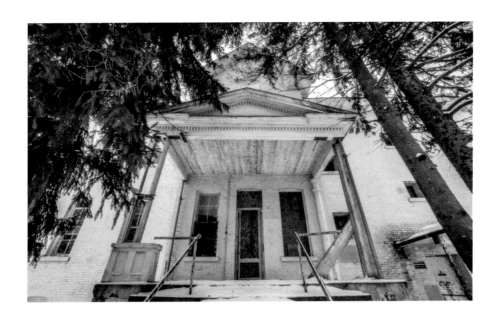

Wastewater Treatment Plant

Nestled in the woods beside a cemetery in Muskegon Heights resides one of only five Brownfield contaminated sites designated by the U.S. Environmental Protection Agency in 2001. Although the list has since grown exponentially, the old wastewater treatment plant remains on it.

Constructed in 1916, this facility was one of several that treated Muskegon County's wastewater. It expanded along with the population's needs, with eight tanks installed in 1936, adding two larger tanks and additional buildings within the next decade. But, by the 1960s, the plants were overwhelmed and outdated, leading to the pollution of several nearby lakes.

The county opened its new plant in 1973, with an impressive irrigation system that could handle as much as forty-two million gallons of wastewater daily, closing the old plant the following year. Since that time, the plant was used by commercial businesses as a hazardous waste management facility until closing for good in 2005.

The property has been eyed for redevelopment as early as 2001, and the city was granted a million dollars and loaned another million for demolition and site cleanup in preparation for senior citizen condominiums and single-family residential units. Plans were halted, however, when the redevelopment company pulled out. The city still planned to demolish the property and sell the land for homes in 2010; however, nearly a decade later, the property remains standing.

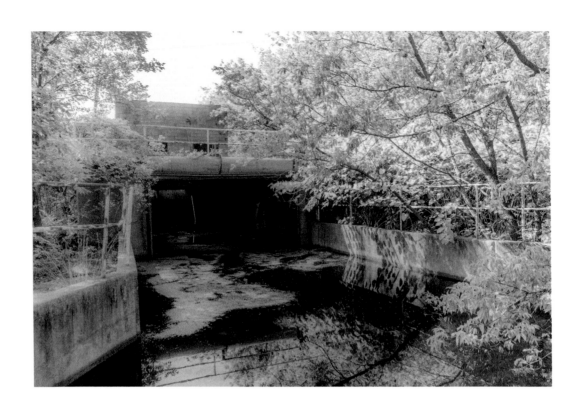

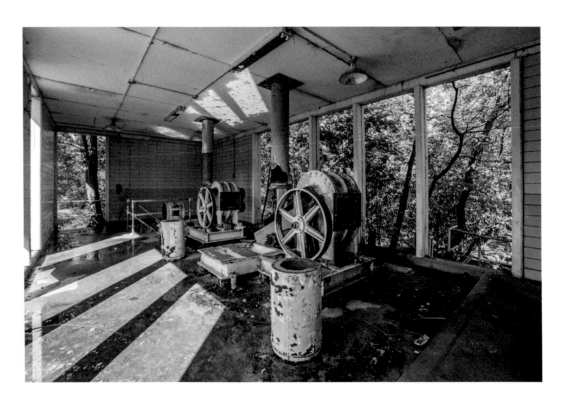

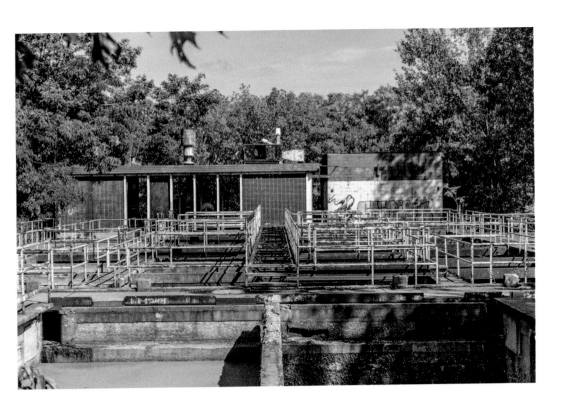

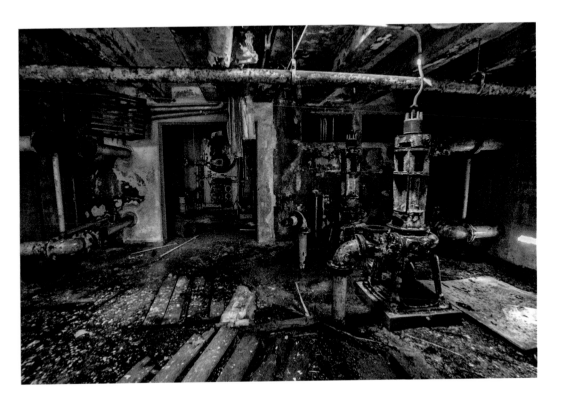

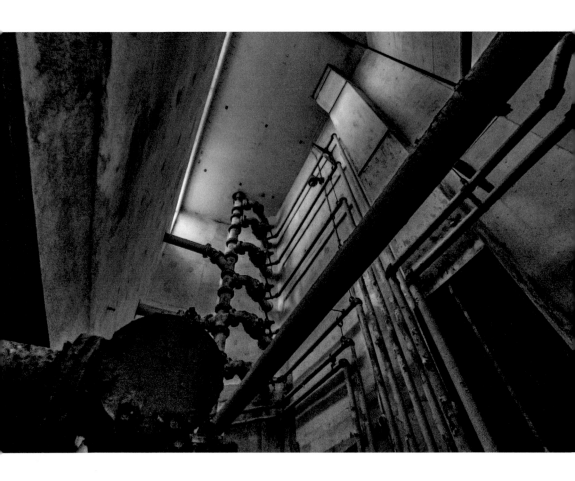

COLLINS MEMORIAL FUNERAL HOME

Opening as late as the 1970s as the Reigle Sunset Chapel Funeral Home in Flint, this large funeral home was purchased by John L. Collins in 1996. It closed around 2006, though prior to that the business had filed for bankruptcy three separate times.

While sitting vacant, it was discovered that the cremated remains of twelve individuals were left behind, though in a police investigation it was determined no laws were violated as they had never been claimed. Across the U.S., there are an estimated 35,000 unclaimed bodies left in funeral homes each year.

Collins Memorial was demolished in 2017, with a Family Dollar now in its place.

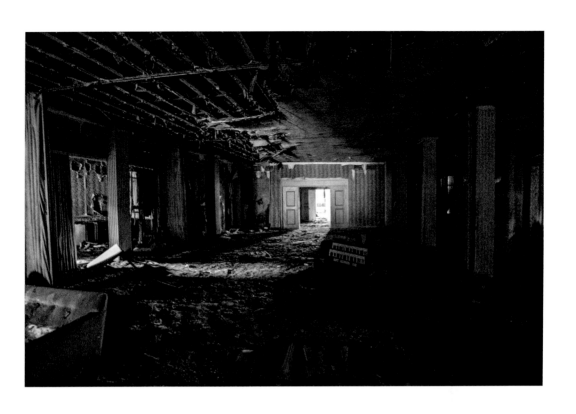

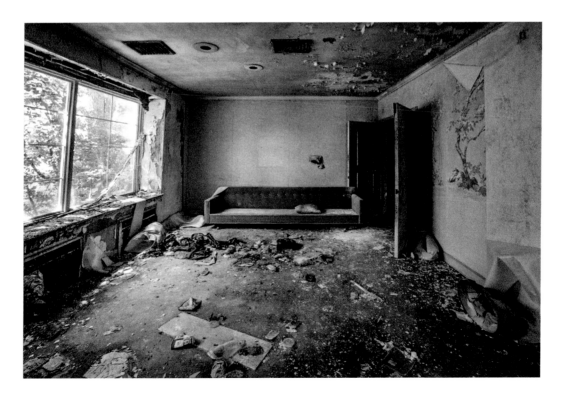

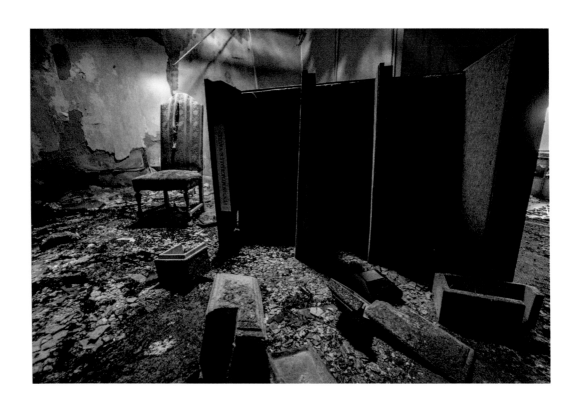

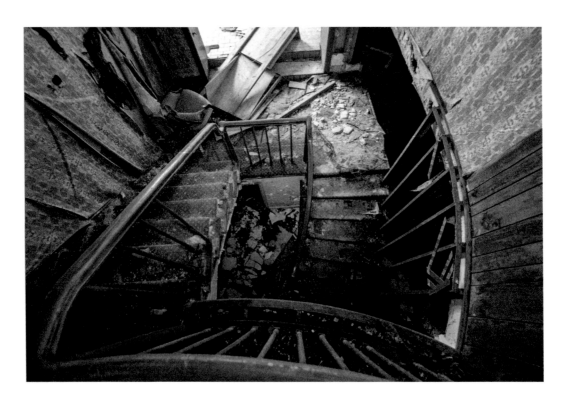

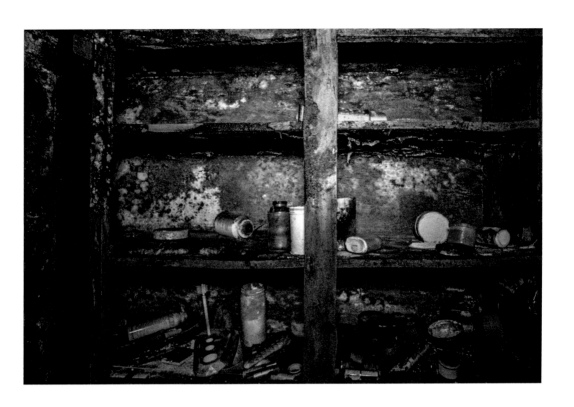

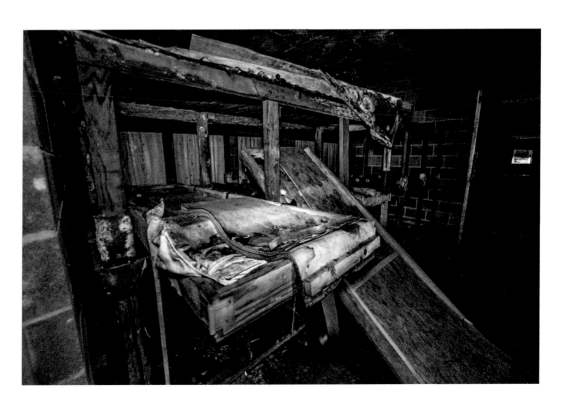

Newaygo Dam

Built in 1900, the Newaygo Hydroelectric Dam sat across the Muskegon River from the Portland Cement factory in the city of Newaygo. Prior to Portland Cement, the area next to the river was home to the Newaygo Furniture Co., Rowe Manufacturing, the Newaygo Separator Co., and Newaygo Engineering.

The dam supplied power to Portland Cement and allowed for water to be extracted and used for slurry, a high water and cement mixture used in construction. Upon the dam's completion, a geological study noted the plant as "one of the finest designed and equipped plants in the State of Michigan." Electricity was provided to the plant via the two 500-horsepower generators, which were driven by eight water wheels.

Readers of the first *Abandoned Michigan* may recall that in the early twentieth century, a newer alternative to the marl used in cement was found, leading many businesses such as the Great Northern Portland Cement Co. in Marlborough to bankruptcy. Portland Cement in Newaygo sold the dam to Consumers Power in 1916, before the cement company closed altogether in the 1920s.

The dam operated until the 1970s and was partially demolished in 1984. Just two years later, a flood broke both remaining operational dams in the area and completely flooded Newaygo.

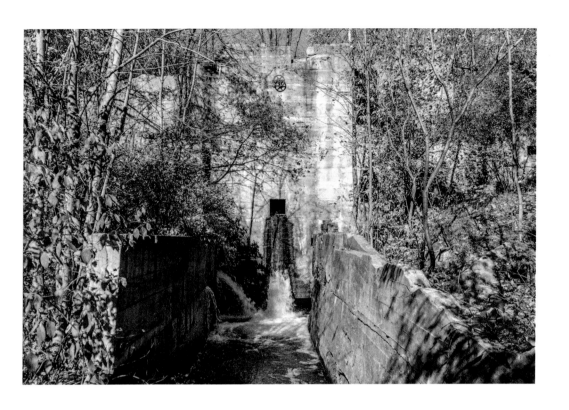

6

HOTELS AND APARTMENTS

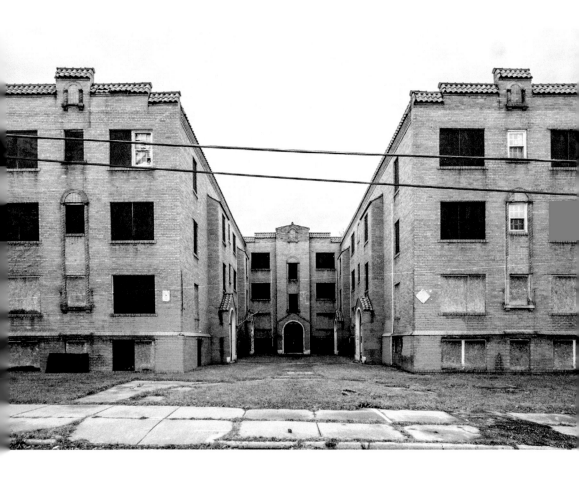

CITY OF DAVID HOTEL

On the back streets of Benton Harbor's half-empty downtown is a shuttered building with quite the history, starting with a traveling preacher and salesman from Kentucky, Benjamin Purnell. In 1895, he and his second wife, Mary, were part of a commune in Detroit which followed their leader, a man proclaiming to be "the seventh messenger," in reference to the final in a series of emissaries as foretold in the *Book of Revelation.*

The pair were thrown out after Benjamin announced to the group that it was actually he who was "the seventh messenger," along with "fire and brimstone await those who doubt me!" The two returned to the road where Benjamin formed his new theology, picking up followers along the way.

The new "King Ben" taught that the end times were near, and that members should prepare themselves instead of focusing on pleasures of the flesh. Sex was forbidden, and members were to not cut their hair, eat meat, drink wine, or even go near a corpse. Any married couples wishing to join were required to call their spouses "brother" or "sister," and all worldly possessions were given over to the group.

After being chased out of Ohio for not attending their own daughter's funeral, Ben and Mary eventually settled in Benton Harbor in 1903, on land donated by a member. Purnell set about sending mass-market books and pamphlets across the country and, by 1916, had amassed more than 1,000 followers.

They prospered, owning 100,000 acres of farmland, which led them to construct the then-world's largest farmers market and cold storage, a resort, restaurant, zoo, and even an entire island on which they logged timber. The House of David baseball team became notorious, playing semi-pro teams across the nation and even taking part in spring training games with Major League teams. An amusement park, Eden Springs Park, drew a half-million tourists each year with a bowling alley, billiards hall, movie theater, shops, and the world's largest miniature railroad.

With all the traffic coming into the area, it only made sense that a hotel was the next step, and King Ben had plans drawn for a magnificent seven-story building in 1919 that was to span an entire city block.

Construction began in 1921, exclusively worked on by the members themselves, but was halted in 1923 when allegations of sexual abuse brought Purnell into the eye of the law. More than 300 witnesses and 15,000 pages of transcripts were presented claiming that the underage girls of this cult, some as young as ten, were forced to have sex with its leader as a necessary step for their salvation.

To make matters worse, whenever authorities attempted to speak with Parnell, he would disappear, even rumored to have a secret vault behind the bear den in

his zoo. Eventually, King Ben showed up to court, carried in on a stretcher and suffering from tuberculosis. The judge ordered he leave the City of David that he founded, though his banishment was not long. He died just months later in 1927.

With his death, the case was closed and left the House of David to split into two separate entities: one run by Purnell's widow, Mary, and aptly named Mary's City of David; and the other by H. T. Dewhirst, a member and former Superior Court judge, who rose to popularity with Benjamin during his legal troubles. Mary's group moved down the road from the original faction but gained ownership of the hotel.

The hotel was finally completed in 1931, though scaled back from its original plan, ending at just four stories on the block corner with ninety rooms. This was due to a combination of the Great Depression and Dewhirst's faction purchasing the adjacent building and opening their own hotel there.

Despite this, the hotel was still quite lavish at the time, as most rooms had their own private bathrooms and it was advertised as fireproof, though some oddities such as a section of closets protruding into the hallway were additions by the builders not originally in the architectural plans.

The ground floor was made up of several shops, including a renowned vegetarian restaurant. It remained profitable over the decades; however, the group's membership began to dwindle. The baseball team disbanded in 1956, and, in the mid-1970s, the amusement park closed and the hotel was traded for lakefront property. It continued operations as the Colfax Inn, and then the Landmark Hotel until converted to elderly housing in the late 1990s.

The building was closed for good after a city inspection in 2001 discovered that the residents had torn open a boiler in the basement to use as a wooden stove, as it no longer was functioning, and leaving them without heat. Dewhirst's hotel building has long since been demolished, and after its closure the remaining hotel was frequently mentioned for renovation but remains empty. Both groups still exist across the street from each other, with less than ten members between them.

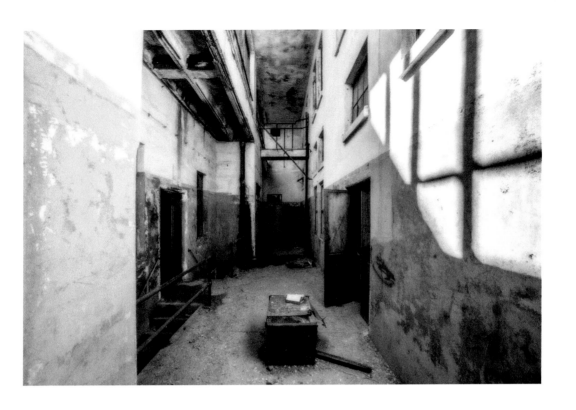

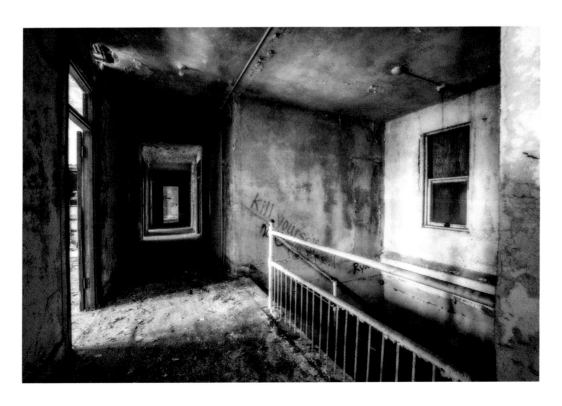

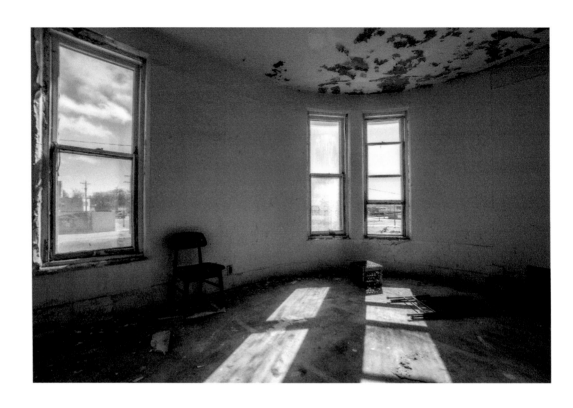

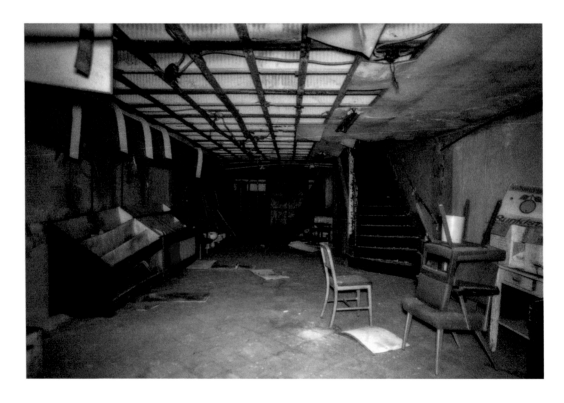

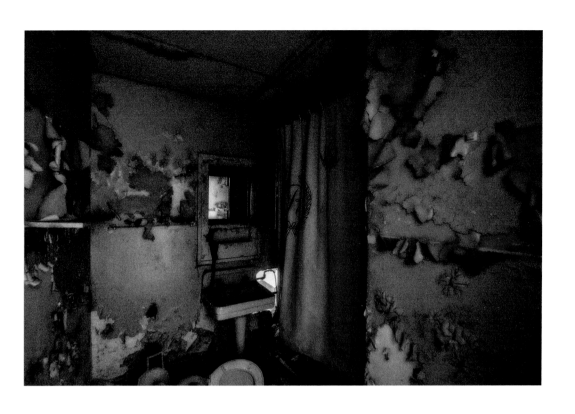

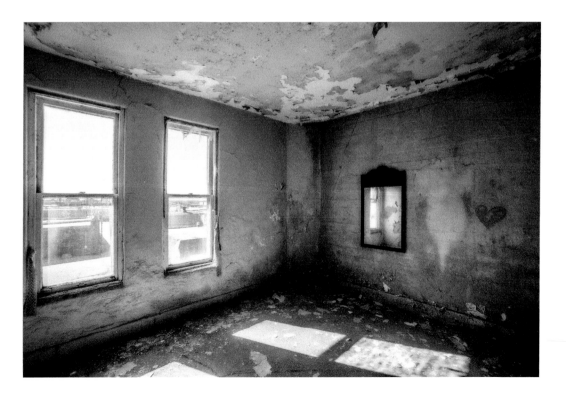

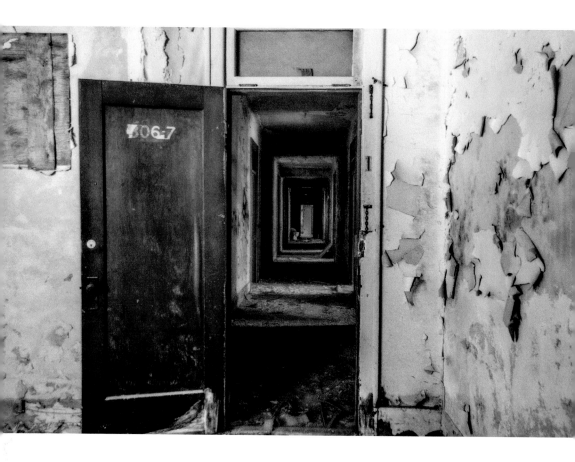

THE HOUSE LANSING

Opening sometime before 1971 as a Hospitality Inn and Sigee's Lounge, this troubled hotel has had a long history. It was eventually acquired by notorious hotelier Leona Helmsley and turned into one of her Helmsley Hotels. Helmsley was long listed as one of the richest people in America, and had been labeled "the queen of mean" for her behavior and treatment of employees. She was later convicted for tax evasion, and the hotel became the Clarion Hotel & Conference Center before closing around the millennium.

The property sat abandoned for more than a decade until renovations began. Named the House Lansing, it was to become Lansing's most luxurious student housing community. Just minutes away from Michigan State University, 150 apartments ranged between studio, one, or two bedrooms, and from 325 square feet up to 975 square feet.

The all-inclusive rent included amenities, handmade furniture, on-site laundry facilities, tennis, volleyball, and bocce ball courts, indoor pool and fitness center, tanning beds, game room, movie theater, study and conference rooms, computer labs, a café, and free shuttles to campus or downtown.

Leasing was to start on this dream location in the fall of 2014, but the time came and went. Only one wing was ever finished. The following year, the building was sold, and a new redevelopment plan came forth in 2016, calling for the buildings to be leveled and six four-story apartment buildings, a ninety-room hotel, and retail center, all with underground parking, to be built. Unsurprisingly, that plan also fell through.

The latest redevelopment plan announced in July 2018 was for a new $52 million apartment complex for medical professionals at Lansing's new hospital that would be constructed and opened in 2020. Nearly six months after the announcement, The House Lansing remains as it has for nearly twenty years: vacant.

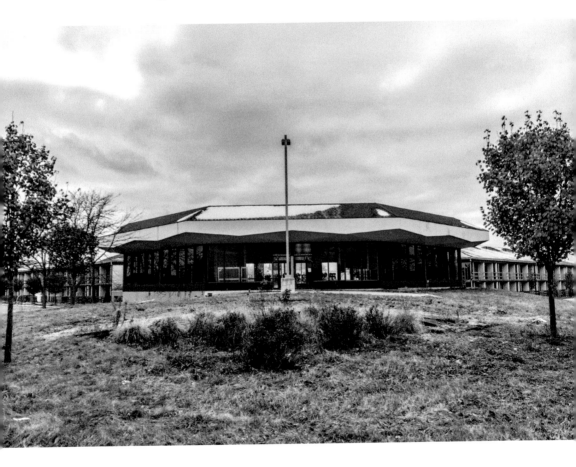

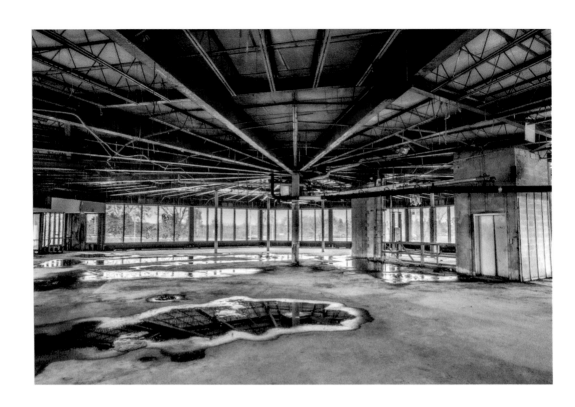

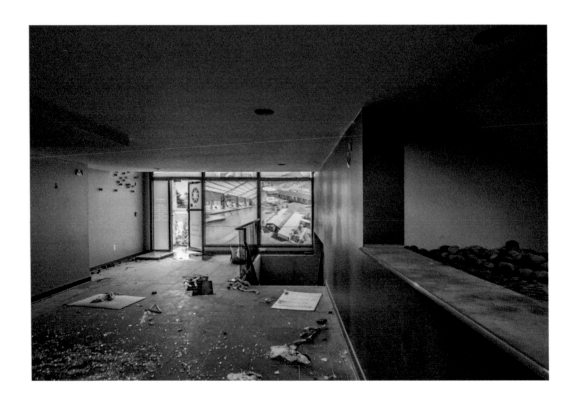

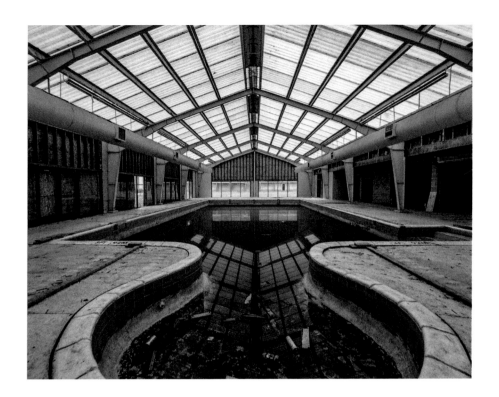

Village Inn Apartments

This forty-three-unit apartment complex was constructed in 1968 in Battle Creek. Numerous bad reviews from tenants complained of nonexistent management, cockroaches, and that drug dealers and prostitutes frequented the building. One review even recommending the place be burned to the ground.

That reviewer got their wish in July 2018, when a fire spread across the building, displacing all eighty residents, seven receiving treatment for smoke inhalation, and leaving two firefighters with minor injuries. While all residents were able to get out without any serious harm, several family pets were not so fortunate.

The cause was later determined to come from the kitchen of one apartment being used as a butane hash oil lab, which produced a marijuana-based drug with a potent high when inhaled. Nineteen empty butane cans, extracting tubes, and marijuana were all discovered in the apartment.

The building was condemned, and the American Red Cross provided aid for the former residents, some of whom were allowed to later retrieve their belongings, though many did not. The complex was demolished in January the following year.

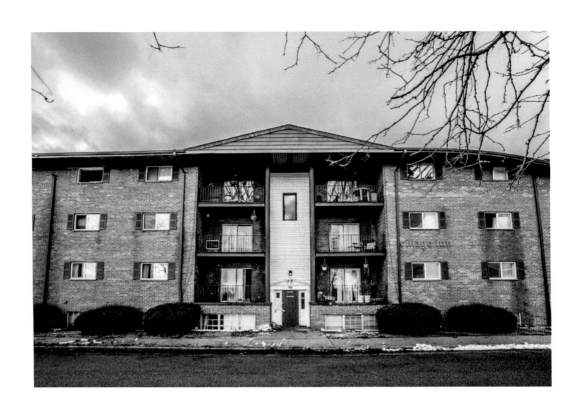

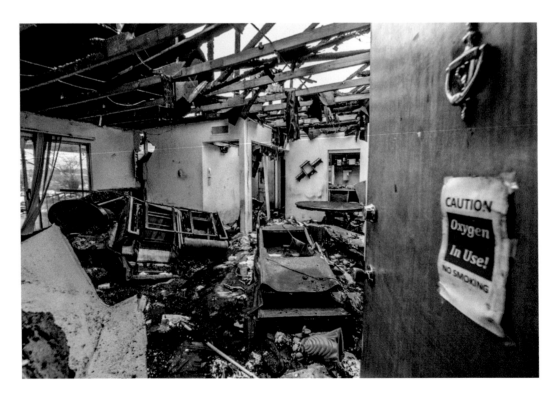

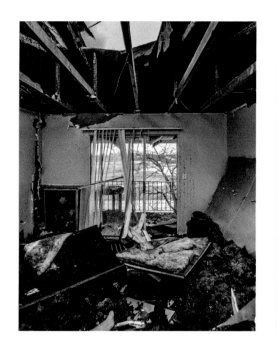

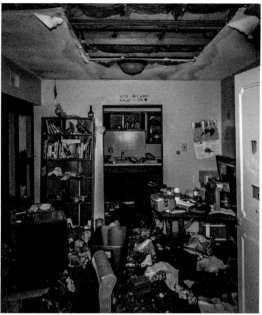

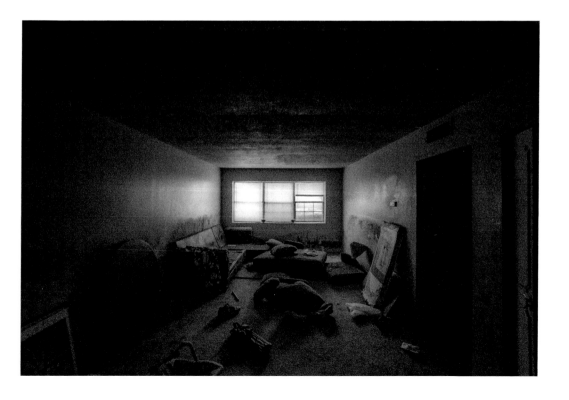

7

ATTRACTIONS AND ENTERTAINMENT

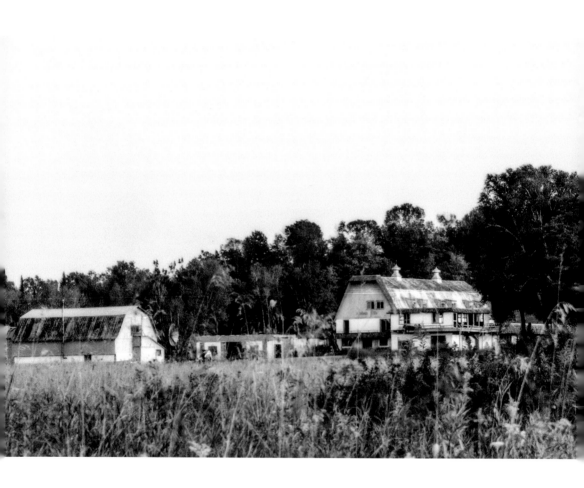

Rosie's Diner

Starting life in 1946 as the Silver Dollar Diner in New Jersey, the diner car restaurant gained fame when it was used as the location of a series of Bounty Paper Towel commercials starting in the 1970s. The diner's fictional tough waitress, Rosie, combatted patrons' spills with "the quicker picker-upper" until her last commercial in the late 1990s.

Out of respect, the restauraunt was renamed Rosie's Diner and moved to West Michigan in 1991. It struggled in its new home until purchased by then-husband and wife Jonelle Woods and Randy Roest in 2006. Together, the pair turned the diner around and Rosie's was consistently ranked as "Best Diner" in local magazines and even featured on an episode of Travel Channel's *Diner Paradise* and Food Network's *Diners, Drive-Ins and Dives* hosted by Guy Fieri.

Soon two more authentic diner cars—one a sports bar, the other a seasonal ice cream shop, along with a miniature golf course—were added. A temporary shutdown for renovations turned into a permanent closure in October 2011. When employees filed for unpaid wages, Jonelle declared personal bankruptcy and the buildings were sold to a neighboring car dealership.

In 2014, Rosie's returned briefly for tours and a car show hosted by the dealership. Since then, the buildings sit mostly forgotten, occasionally seeing another car show or being used as a filming location on short films.

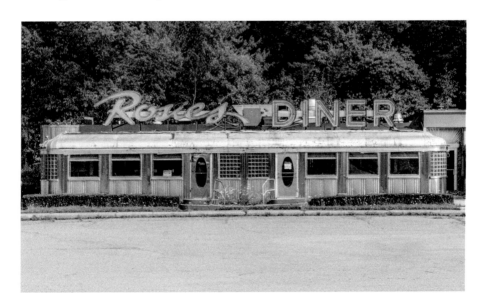

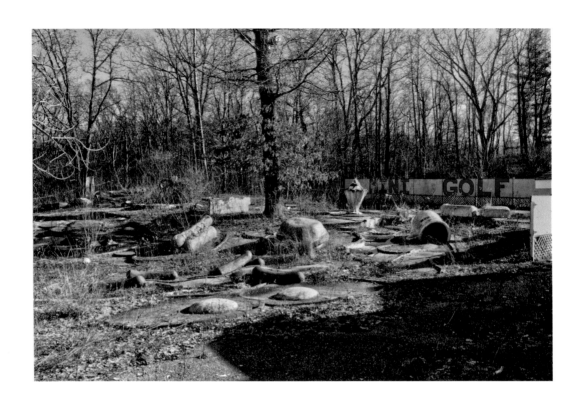

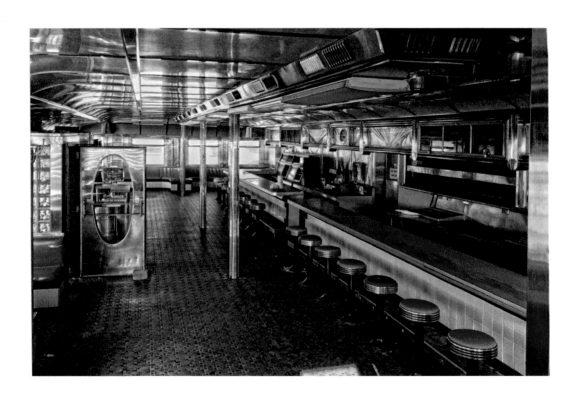

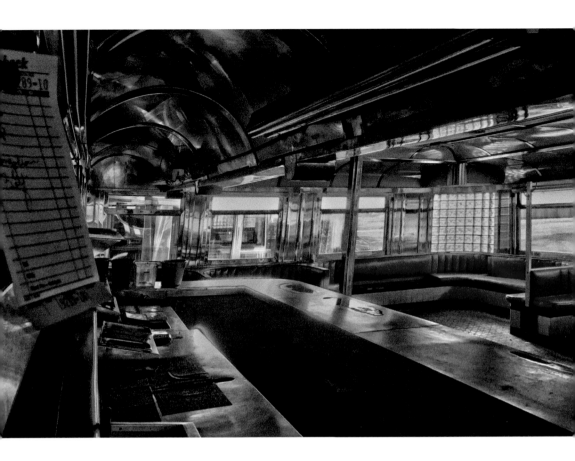

ESTELLE HAUNTED HOUSE

In the farmland between Traverse City and Gaylord rests this abandoned home-turned-haunted-attraction and hayride. The attraction's Facebook page tells a generic backstory of the haunted house featuring murder, necrophilia, dolls, and torture.

However, long before being a Halloween haunted house, it came to be rumored as an actual haunted house by local ghost hunters, and a separate tale of the home's history is told: Legend has it that a drifter came to the farm in the 1800s looking for work. Instead, he murdered the entire family: parents, three sons, and two daughters, the youngest of whom was found hanging in the shed outside.

None of this has been validated, but it hasn't stopped the reports of cold spots, whispering, footsteps, and even being scratched while inside. The haunted house attraction ran for just one season. Since then, the house has remained vacant.

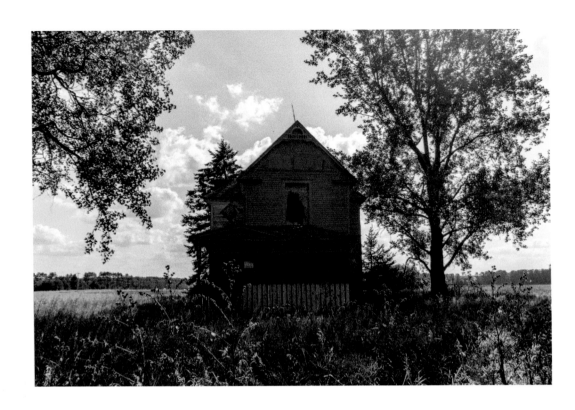

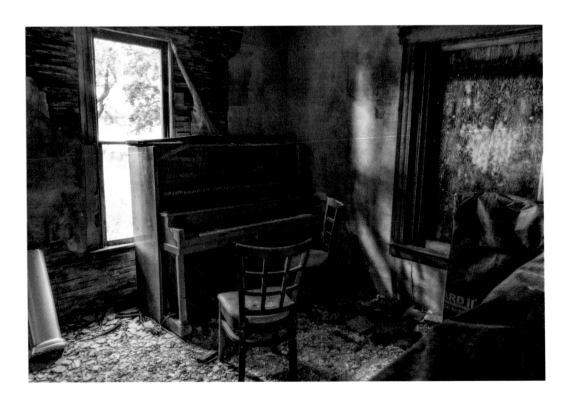

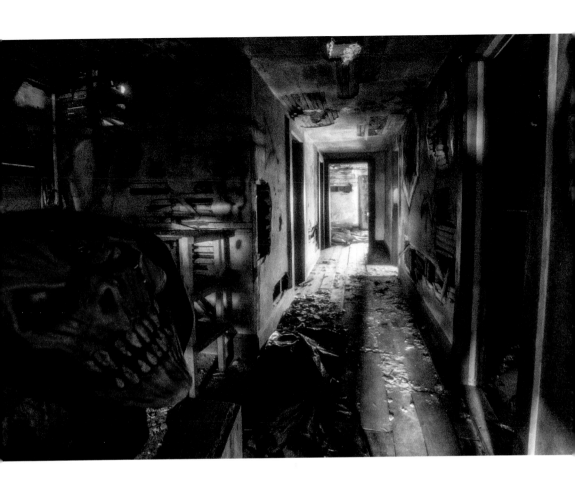

GOOD SHEPHERD SCENIC GARDENS

First opening in 1953, this "concrete sanctuary," as it is known, was moved to its current location near Kalkaska in 1973. A biblical walk was located to the left of the sanctuary where visitors could see various scenes from the Bible recreated via concrete statues. At some point, this section was closed with only the sanctuary remaining open for business.

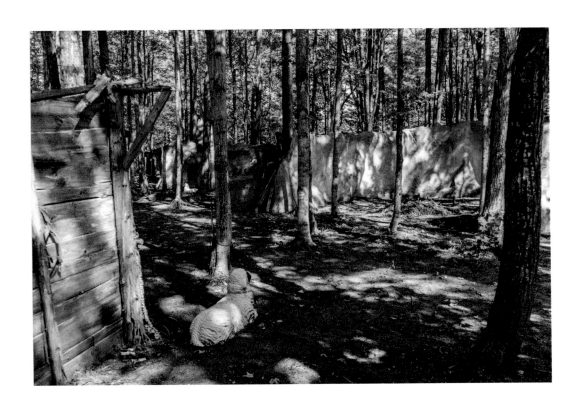

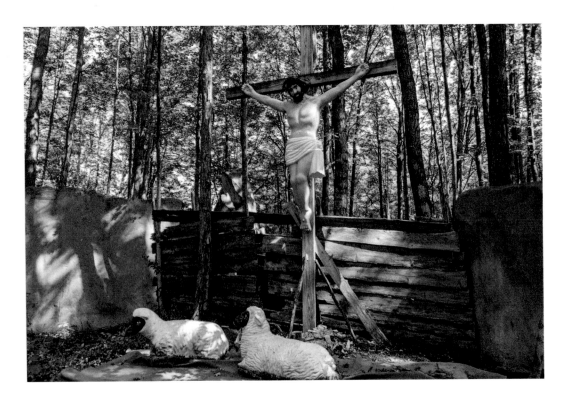

Pebble Brook Fun Park

Pebble Brook was an amusement center located across from the bay in Traverse City, and opened in 1984. It featured two eighteen-hole mini-golf courses, go-carts, an arcade, a game room, and an ice cream store. The older business could not compete when a newer and larger mini-golf course and adventure center, Pirates Cove, was opened just down the road.

Online reviews complain of the facility being rundown and overgrown before it closed in 2014. A public auction was held and most of its inventory was sold. The property remained vacant until drawing the eye of developers, who in 2018 announced interest in constructing a hotel on the property, planning to open the following year. Pebble Brook remains standing in 2019; however, the main building has been reduced to a shell, with the windows removed and electrical wiring torn out in preparation for demolition.

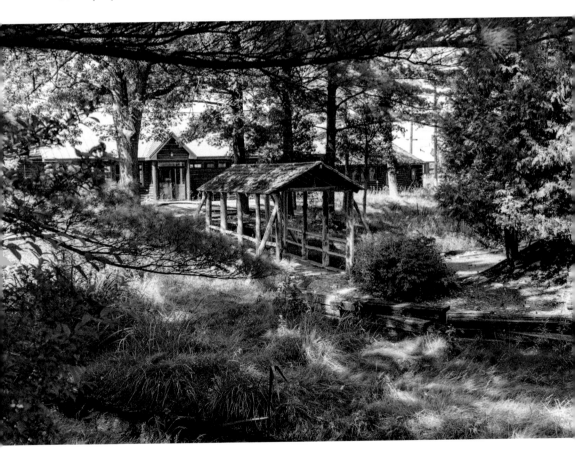

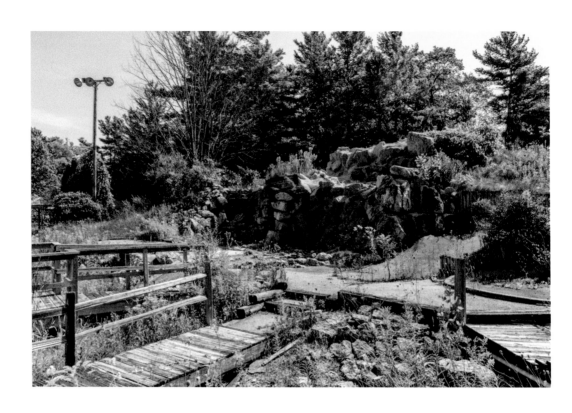

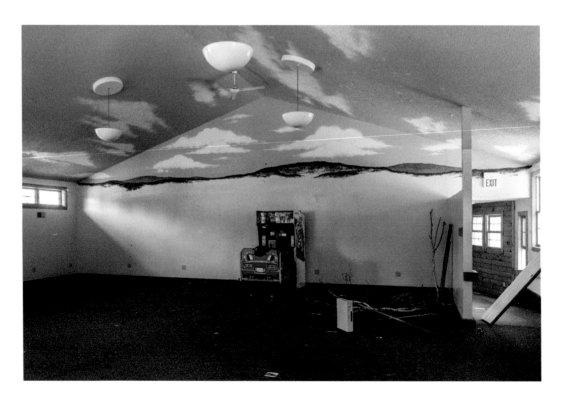

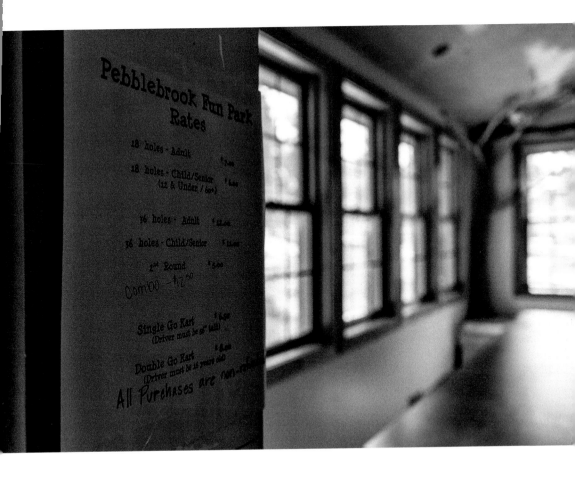

Odd Fellows Valley Lodge No. 189

The International Order of the Oddfellows is a fraternal organization founded in the early 1700s. The group promotes personal and social development for the good of humanity. Their first lodge in America was constructed in 1819, with Lodge 189 being constructed in Bay City in 1928.

The Odd Fellows and their sister organization, the Daughters of Rebekah, were founded in the area back in 1869 and had rented locations until constructing their first building on the location of Lodge 189 in 1898. The building was expanded when their current building had become too small for the growing membership.

It is reported that a dead body was found in the basement of the building in 1981. The cause of death listed as unknown, this was reported by local ghost hunters who claim the building is haunted, but unconfirmed. However, a confirmed and

much more elaborate crime story took place in the building just a few years before it was converted into an Odd Fellows lodge, and was also noted as Bay City's worst crime ever committed.

On a cold January day in 1921, five members of notorious bandit and killer Steve Madaj's gang held up the Bay County Savings Bank, which was located in the building at that time. The robbery left two patrons dead, and the gang abandoned their vehicle nearby and escaped, despite the enraged townspeople patrolling the area with ropes ready to capture them.

A $15,000 reward (roughly $212,000 today) was posted for information leading to their arrest, but the criminals were eventually caught after it was noticed that the unemployed gang members had suddenly begun making large purchases.

Through questionable police tactics, it was determined that Madaj had planned the heist from his jail cell in Jackson Prison and that the temporary gang leader, Aloysius Nowak, had been the shooter of both victims. Guards were placed on duty to protect the suspects from lynch mobs, and the trial was forced to be held in secret.

Nowak and two other robbers were sentenced to life in jail, with the other two gang members receiving reduced sentences. Believing his former boss had turned him in, Nowak confessed to police that Madaj had committed a previously unsolved murder of a Bay City lumber baron, who was shot to death in the middle of the street in 1918.

The bank was moved to another location in the early 1920s when the Odd Fellows purchased the building, which they used until moving elsewhere in 1979 due to a dwindling membership. A television repair shop is noted as using the building in the 1980s before it sat empty until purchased by the city in 2004 after it was declared unsafe.

The city planned to convert the building into a police station, but eventually scrapped the idea, instead selling it in 2009 to a local developer who was purchasing several unused properties in the area. It was announced that the building would be turned into a vocational school; however, the developer was convicted of tax fraud in 2015, and its fate remains in limbo.

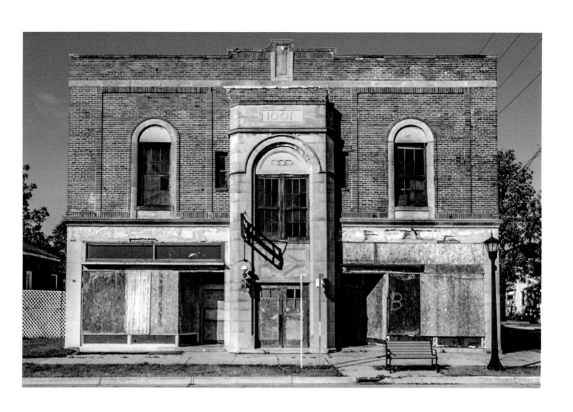

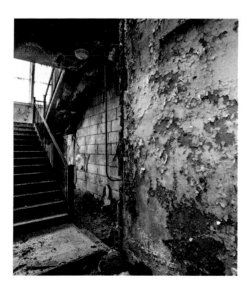
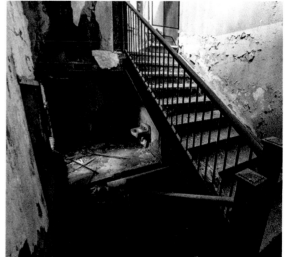

8

HOMES

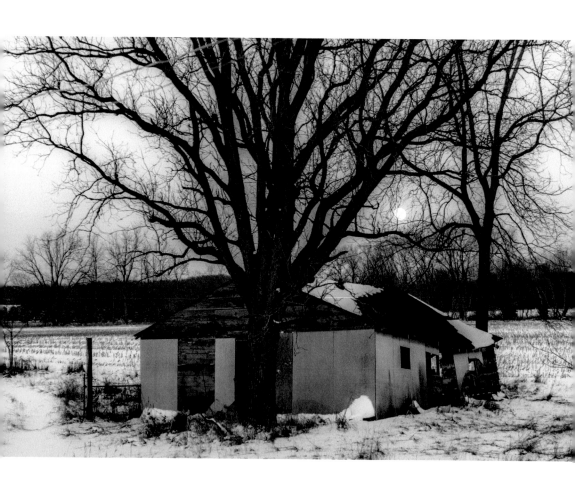

Art Deco Mansion

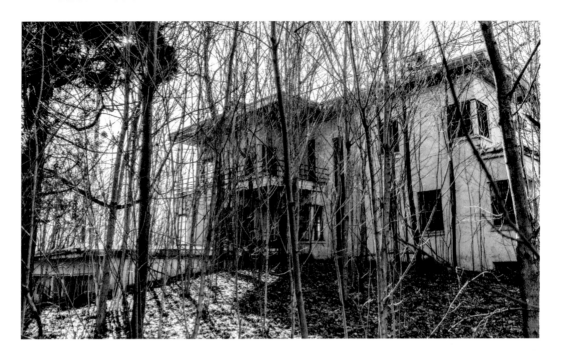

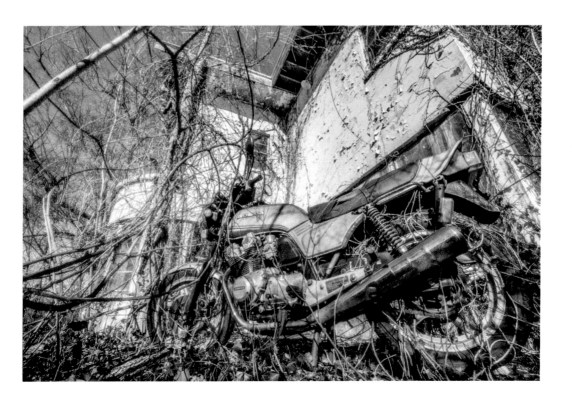

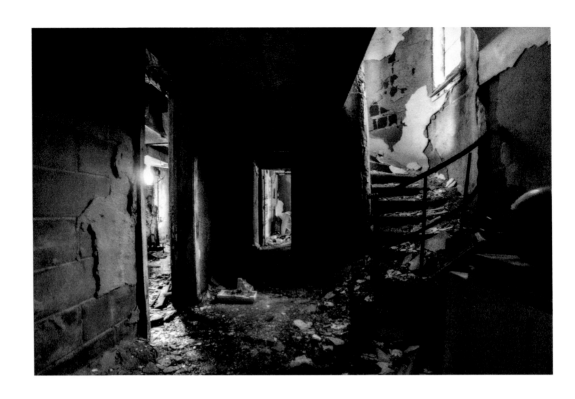

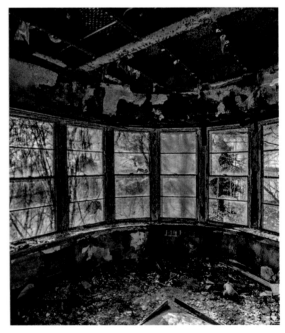

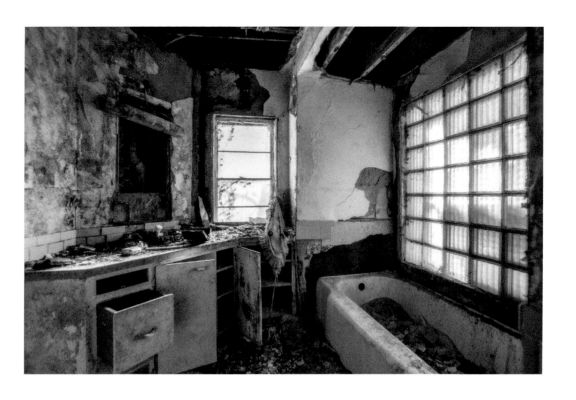

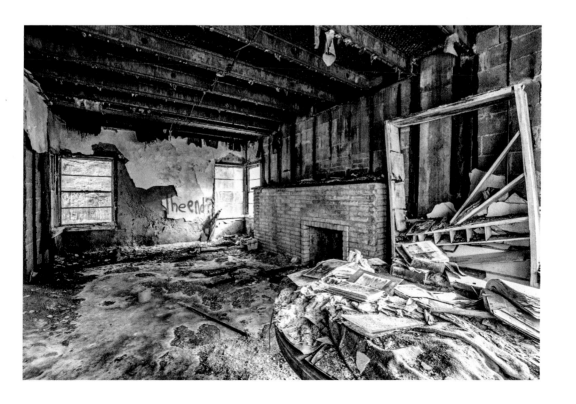

Farmhouse

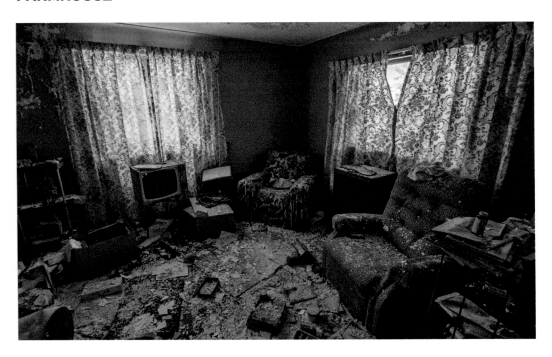

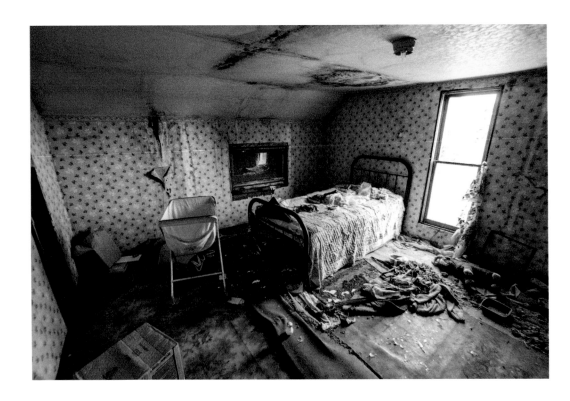

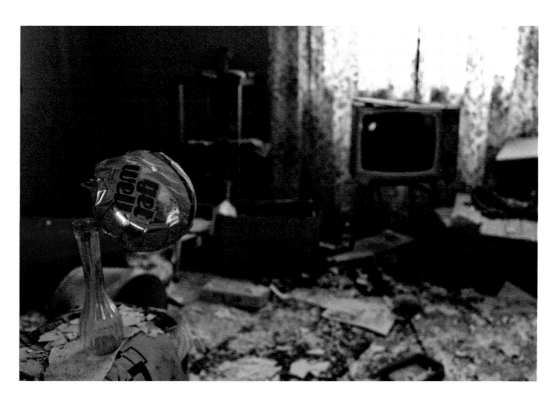

Mystery House

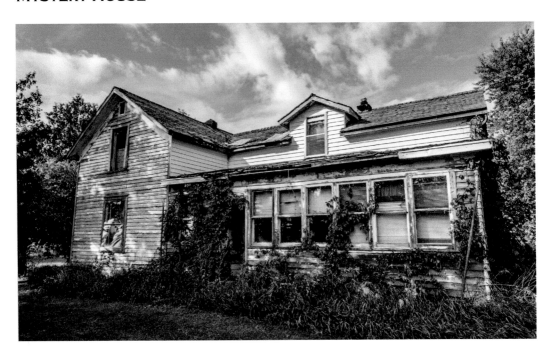

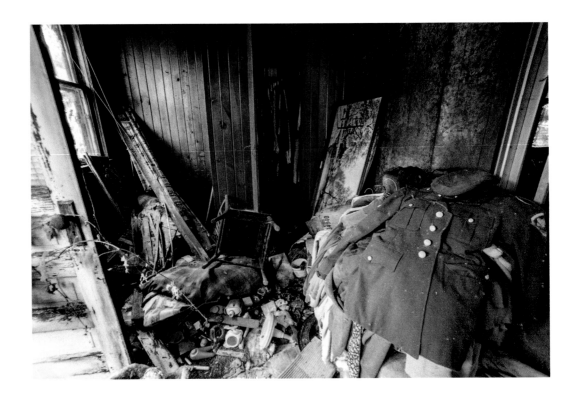

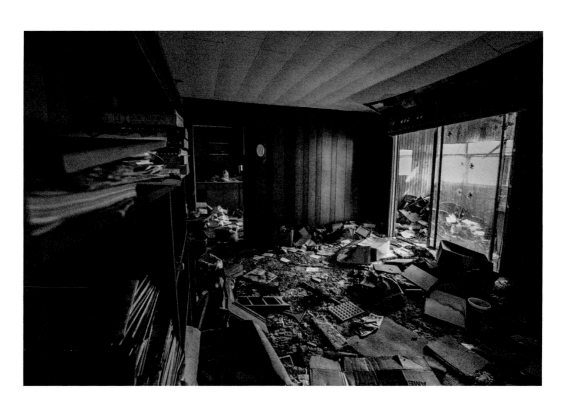

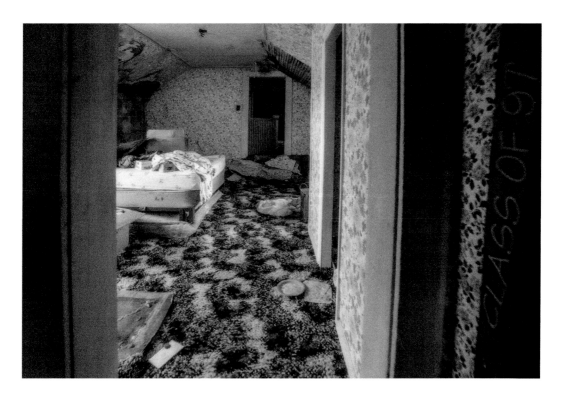

MISCELLANEOUS

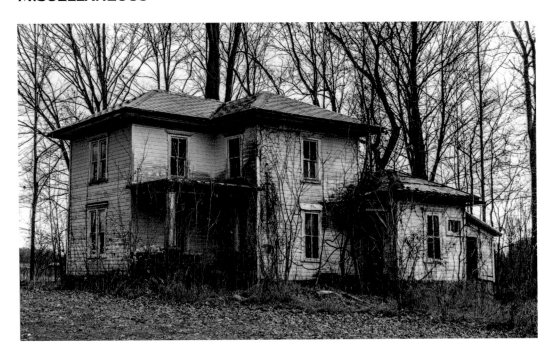

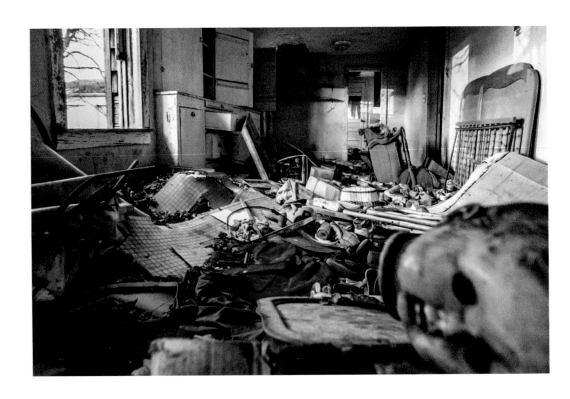

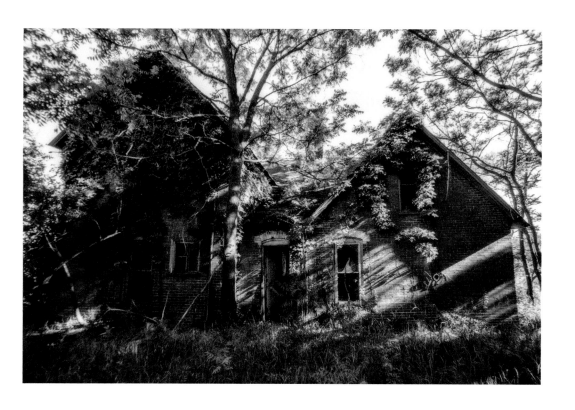

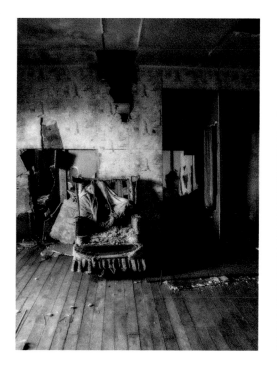

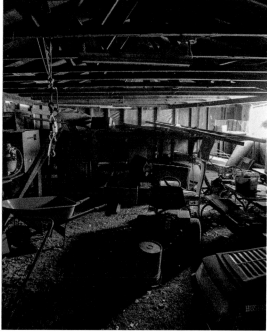

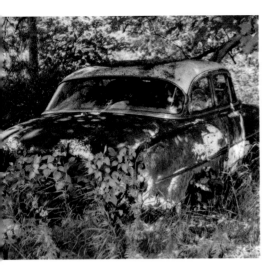
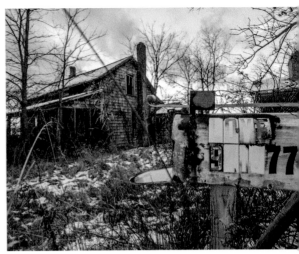
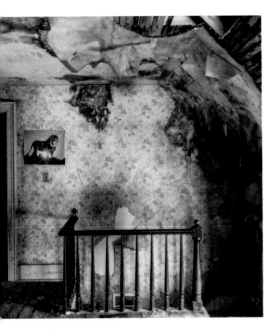
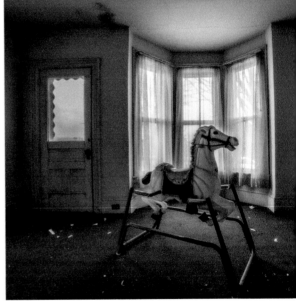

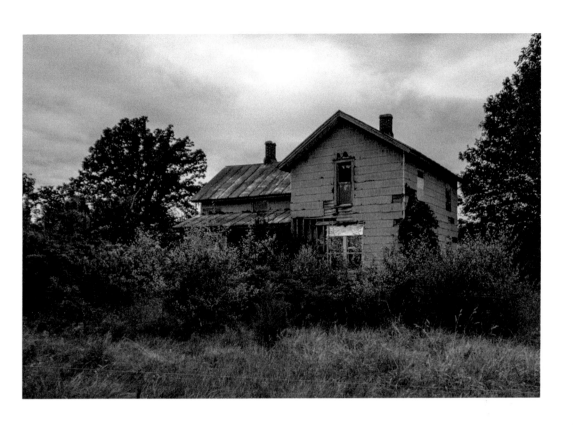

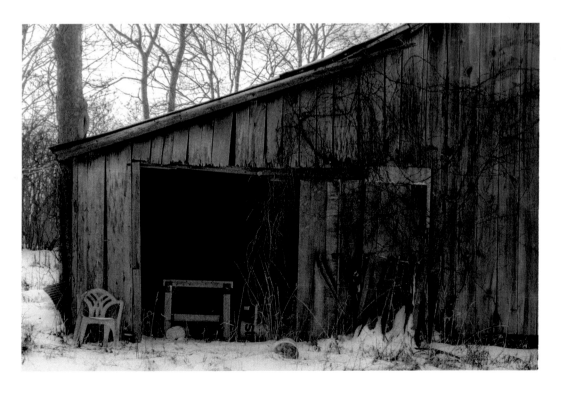

BIBLIOGRAPHY

Jones, Rob, director. *Lookout Park St. Joe, MI. YouTube*, YouTube, 14 Jan. 2013, www.youtube.com/watch?v=f39p29uUTbQ.

Kussmann Latus, Lois. "Catholic Church History in Hartford, Michigan." *Pearls In Our Past*, Emma Thornburg Sefcik, 10 July 2010, www.hartfordmichigan.com/wwwroot/hartfordhistory/Churches/Catholic%20Church%20documented%20History-present.htm.

eCatholic. "St. Joseph Catholic Church." *St. Joseph Parish*, stjcatholic.net/history.

Community History. Community History, Historical Society of Clinton, 2011, www.villageofclinton.org/images/Community/timeline.pdf.

Bradish, Jay K. "On The Job - Michigan: 9-Alarm Fire Destroys Clinton Mill." Firehouse, 1 July 2008, www.firehouse.com/home/news/10502593/on-the-job-michigan-9alarm-fire-destroys-clinton-mill.

Burko, Casey. "Saving Lake Shore's No Day at the Beach." *Chicago Tribune*, 25 Jan. 1987.

Frownfelder , David. "Historic Clinton Mill Must Be Torn Down." *The Daily Telegram*, 14 March 2009.

Grossman, Ron. "A Cult in Benton Harbor: The Good and (Alleged) Evil of the House of David." *Chicago Tribune*, 16 July 2017.

Kane, Jim. "Mooreville Revisited." *Ann Arbor News*, 12 March 1972.

"Michigan." *Sperling's Best Places*, Fast Forward Inc., 2019, www.bestplaces.net/state/michigan.

"Carson City, Cedar Lake, Butternut." *Montcalm County 1897*, Geo A. Ogle and Co., 1897.

"Railroads." *County of Montcalm, Michigan*, www.montcalm.us/community/community_a_-_l/railroads.php.

Decker, William A. *Northern Michigan Asylum: A History of the Traverse City State Hospital*. Arbutus Press, 2010.

Crawford, Kim, and Bryn Mickle. "No Laws Broken at Funeral Home." *The Flint Journal*, 16 May 2006.

DeMott Discoveries. "Our Transport Heritage." Our Transport Heritage, 20 Nov. 2017, ourtransportheritage.com/index.php/2017/11/20/mr-millers-airport/.

Snyder, Dave. "The History of the Portage Lake Observatory." University Lowbrow Astronomers, 1998, umich.edu/~lowbrows/history/portage-lake.html.

James, Brandon. "Amazing Photos Bring Barry County's Martin Corners to Life." WBCK-FM, 12 May 2018, wbckfm.com/amazing-photos-bring-barry-countys-martin-corners-to-life/.

Greystar, director. *The House | Lansing MI Apartments | Greystar Apartments. YouTube*, YouTube, 10 Aug. 2015, www.youtube.com/watch?v=HNYOcokTOcA.

"THE HOUSE Apartments - Lansing, MI." *Apartments.com*, 1 Jan. 2019, www.apartments.com/the-house-lansing-mi/hxxvz93/.

Lansing City Council. (2016, October 27). Committee on Development and Planning. www.lansingmi.gov.

Hansen, Haley. "Developer Plans $52M Apartment Complex." *Lansing State Journal*, 16 July 2018.

Editors, TheFamousPeople.com. "Leona Helmsley Biography." TheFamousPeople.com, 28 Aug. 2017, www.thefamouspeople.com/profiles/leona-helmsley-35002.php.

Higgins, Kendra. "Allen." *Hillsdale County Historical Society*, 2018, www.hillsdalehistoricalsociety.org/allen-mi/.

Christenson, Trace. "Charges Considered in Village Inn Apartment Fire." Battle Creek Enquirer, 19 Sept. 2018.

Frank, Annalise. "Nonprofit Aims to Renovate Pontiac Middle School." Crain's Detroit Business, 20 Feb. 2018.

Terry, Jermont. "Pontiac Homeowners Unhappy about Developer's Plan for Vacant School Building." WDIV-TV, 5 Feb. 2018.

"HISTORY OF BAKER PERKINS INC, SAGINAW." *Baker Perkins Historical Society*, www.bphs.net/ groupfacilities/s/saginaw/index.htm.

9And10news Site Staff. Episode: "Jack's Journal: Robinson's Scenic Gardens," CBS, 18 Aug. 2014.

Manning, Craig. "Developers Eye Three New Traverse City Hotels." *The Ticker*, 12 Mar. 2018.

"Our Mission." *Independent Order of Odd Fellows*, 6 Aug. 2018, odd-fellows.org/about/our-mission/.

Murphy, Shannon. "Local Developer Plans to Restore Former Odd Fellows Hall on Broadway in Bay City." *Mlive*, 21 Oct. 2009.

Rogers, Dave. "Worst Crime in Bay City History Occurred 90 Years Ago January 15." *Mybaycity.com*, 16 Jan. 2011.

Wiregirl1224. "ORS+GT - Clarks Corners." *Geocaching*, 27 Dec. 2015, www.geocaching.com/geocache/ GC68QDJ_orsgt-clarks-corners?guid=897dfd0a-07ab-4099-ba0b-b0daffb0271b.

Parshall, Lorene. "'Slaughter House' Open for Business." *Gaylord Herald Times*, 17 Oct. 2013.

Martinez, Shandra. "TV Favorite Rosie's Diner in West Michigan Closes." *Deseret News*, 12 Oct. 2011.

Giles, Anna. "Mattawan Residents Wary about Abandoned Mobile Home Park." 18 Oct. 2017.

United States, Congress, BOARD OF GEOLOGICAL SURVEY , and David J Hale. "GEOLOGICAL SURVEY OF MICHIGAN LOWER PENINSULA 1900-1903." *GEOLOGICAL SURVEY OF MICHIGAN LOWER PENINSULA 1900-1903*, III ed., VIII, ROBERT SMITH PRINTING CO, 1903, pp. 36–37.

Fury, Tom. "Newaygo Portland Cement Company." *The October Project*, 26 Aug. 2009, theoctoberproject. com/places/pnts_of_interest/Cement/.

Sonnenberg, Mike. "The Ghost Town of Fern." *Lost In Michigan*, 10 Nov. 2018, lostinmichigan.net/ ghost-town-fern/.

Smith, Denice. "MASON COUNTY." *Michigan One Room Schoolhouses*, 2 June 2015, michiganone-roomschoolhouses.blogspot.com/2015/06/mason-county.html.

Carlisle, John. "Benton Harbor Remembers Cult Destroyed by Sex Scandal." *Detroit Free Press*, 13 Nov. 2016.

Baldwin, Thomas, and Joseph Thomas. *A New and Complete Gazetteer of the United States: Giving a Full and Comprehensive Review of the Present Condition, Industry, and Resources of the American Confederacy ...* Lippincott, Grambo, 1854.

"Leonidas Township, Factoryville, Havens Lake." *St. Joseph County 1930*, Brock and Co., 1930.

"Leonidas Township, Factoryville PO." *St. Joseph County 1893*, E.P. Noll & Co., 1893.

Brost Reck, Mary. "Church Demolition on Hold." *Tri-City Record*, 13 Feb. 2014.

Gaertner, Eric. "Muskegon Heights Has New Plan for Redevelopment of Former Wastewater Site." *Mlive*, 2 Aug. 2010.

"History - MUSKEGON COUNTY WASTEWATER MANAGEMENT SYSTEM." MUSKEGON COUNTY, muskegoncountywastewatertreatment.com/about-us/history/.

MORE BY KYLE BROOKY

ABANDONED MICHIGAN
ISBN 978-1-63499-100-1
$24.99

ABANDONED DETROIT
ISBN 978-1-63499-118-6
$24.99